THE
ENCYCLOPEDIA
of
PHOTOGRAPHY

THE
ENCYCLOPEDIA
of
PHOTOGRAPHY

An A-to-Z Visual Directory, with an
Inspirational Gallery of Finished Works

ADRIAN DAVIES

Running Press
PHILADELPHIA · LONDON

A QUARTO BOOK

Copyright © 2000 Quarto Inc.

All rights reserved under the Pan-American and
International Copyright Convention.
First published in the United States in 2000 by
Running Press Book Publishers.

9 8 7 6 5 4 3 2 1

Digit on the right indicates the number of this printing.

ISBN 0-7624-0704-2

Conceived, designed, and produced by
Quarto Publishing plc
The Old Brewery
6 Blundell Street
London N7 9BH

QUAR.EOPT

Project editor Michelle Pickering
Art editor & designer Sheila Volpe
Assistant art director Penny Cobb
Text editor Casey Horton
Illustrator Tony Walter-Bellue
Picture researchers Laurent Boubounelle, Frank Crawford
Indexer Dorothy Frame

Art director Moira Clinch
Publisher Piers Spence

Manufactured by Regent Publishing Services Ltd, Hong Kong
Printed by Leefung-Asco Printers Ltd, China

This book may be ordered by mail from the publisher.
Please include $2.50 for postage and handling.
But try your bookstore first!

Running Press Book Publishers
125 South Twenty-second Street
Philadelphia, Pennsylvania 19103-4399

Visit us on the web!
www.runningpress.com

SAFETY NOTICE

Some photographic techniques, such as those involving the use of
developing chemicals, can be hazardous, and readers should follow
procedures and wear appropriate protective clothing at all times. Neither
the author, copyright holder, nor publishers of this book can accept legal
liability for any damage or injury sustained as a result of taking or
developing photographs, or using any other photographic technique.

Contents

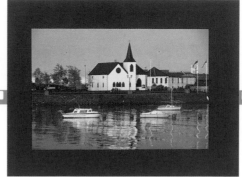
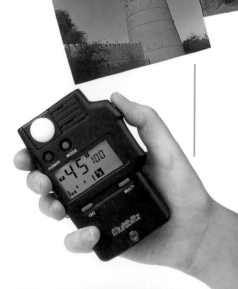

PROCESSING & PRESENTATION

DIGITAL IMAGING

GALLERY

INTRODUCTION

Photography is a fascinating combination of art and science. It is dependent on technology in the form of cameras, lenses, lights, and film (and its associated chemical processes), but also offers the creative potential to produce interesting and informative images, often from everyday, mundane objects.

The very best photographs are taken by those who have mastered the technical aspects and have an "eye" for a picture – that is, they are able to visualize a good image, often under difficult conditions. However, photography does not end with the camera and the taking (or making) of photographs; it also encompasses the various darkroom processes of developing film and enlarging the negatives to produce photographic prints. Even the final stage of presentation and mounting can enhance the finished image, and therefore needs to be given careful consideration.

The main photographic equipment and processes have remained fundamentally unchanged for over a century, but during the last few years there has been a revolutionary improvement in the way images are produced, with digital cameras and computers replacing darkrooms. Printing techniques too are evolving rapidly, making it possible to produce photographic quality prints using inexpensive desktop ink jet or laser printers.

Yet whichever way you choose to record images, process and print them, there is little doubt that photography is a great art form. It was available to record the major events of the 20th century, as well as produce some of the most memorable images. Now, in the 21st century, there will undoubtedly be further changes in technology, but the ability of the photographer to record the world in which we live will remain unaltered.

▲ CHOOSING HARDWARE
Modern photographic film can bring scenes such as this alive, capturing the vivid hues and subtle nuances of the flowers' colors. Knowing the right type of film and other equipment to use will help you achieve good results.

▶ THE RIGHT TECHNIQUE
A subject like this could be mundane were it not for the "eye" of the photographer, framing the boats with the colorful nets in the foreground. Experimenting with techniques such as framing will help you create more successful photographs.

HARDWARE

HARDWARE IS THE EQUIPMENT THAT YOU NEED TO
TAKE PHOTOGRAPHS. IN ADDITION TO A CAMERA AND
LENS, YOU MAY ALSO NEED OTHER DEVICES, RANGING
FROM FILTERS FOR THE FRONT OF THE LENS, TO LIGHTS
FOR ILLUMINATING YOUR SUBJECT. HARDWARE ALSO
INCLUDES FILM, WHICH MUST BE EXPOSED CORRECTLY.
THIS SECTION OF THE BOOK LOOKS AT THE HARDWARE
REQUIRED FOR PHOTOGRAPHY, EXAMINES THE VARIOUS
PIECES IN TURN, AND EXPLAINS THE WAY IN WHICH
THEY RELATE TO EACH OTHER.

Cameras

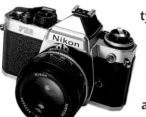

Although there are literally dozens of different types of camera, they all have certain things in common: they are all basically lighttight boxes that admit controlled amounts of light through a lens onto a light-sensitive recording medium, usually film.

Recently, digital cameras have become available in which silicon chips called CCDs (Charge Coupled Devices), containing thousands or millions of light-sensitive pixels (picture cells), replace the film. The two types of camera used by the majority of photographers are the compact and the single lens reflex (SLR), although many professionals also use large format "monorail" cameras, panoramic, and twin lens reflex as well.

COMPACT CAMERAS The compact is basically an "all in one" camera without the facility of interchangeable lenses. Its major feature is that the subject is viewed through a simple lens in a viewfinder, which is different from the lens that actually takes the picture. Compacts are sometimes known as "direct vision" cameras, because the subject is viewed directly through the lens in the viewfinder (rather than through a mirror system that transfers the image from the picture-taking lens to the viewfinder window; see SLRs, page 11). This can result in parts of the picture being cut off, particularly when taking close-ups of the subject. This problem is known as "parallax," and is rather like viewing something with your left eye, and photographing it through the right.

Most compact cameras have an automatic exposure system, with little scope for setting controls manually. They either have a fixed focal length lens or a zoom lens. They are available either in the 35mm film format, or in the recently introduced

☞

Exposure, pages 18–21
Film, pages 22–25
Lenses, pages 26–31
Light sources,
pages 32–37
Photographic
accessories,
pages 38–39
Filters, pages 58–63

COMPACT CAMERA

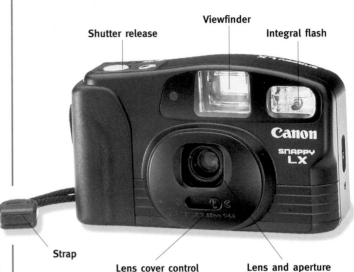

Shutter release · Viewfinder · Integral flash · Strap · Lens cover control · Lens and aperture

▲ This example of a 35mm compact camera has built-in flash, automatic focusing, and a fixed focal length lens.

PARALLAX

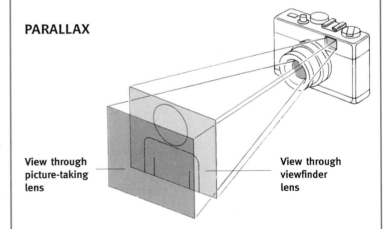

View through picture-taking lens · View through viewfinder lens

▲ The image seen through the viewfinder on a compact camera is slightly different from that seen by the picture-taking lens, so the image recorded on the film will be slightly different from the image viewed. This parallax error will be insignificant at medium or long distances, but does become a problem with close-up work.

APS (Advanced Photographic System) format, which allows you to define different print formats (that is, normal, wide, and panoramic) as you shoot the film (see Film). Most compacts have built-in flash, while advanced models have facilities for recording the date and time the picture was taken, or for reducing the effect of "red eye" in portraits (see Light Sources).

Compacts have a limited use in creative photography, but are very useful for keeping in the pocket at all times, either to act as a type of visual notebook or in case an unexpected photographic opportunity arises.

SINGLE LENS REFLEX CAMERAS (SLRs) SLRs solve the problem of parallax by viewing and photographing the subject with the same lens. This is achieved with a movable mirror system and a focal plane shutter that is situated immediately in front of the film, which also allows you to remove the lens from the camera without exposing the film. An SLR lets you see almost exactly what you are going to photograph, including the effect of any filters placed over the lens. SLRs are available in 35mm and APS format, as well as the larger 120 film format, and are preferred by many amateur and professional photographers. SLRs are light and extremely versatile, and are used by photographers for subjects such as sports, news items, wildlife, and fashion. There is a large range of available lenses for SLRs, as well as a host of other accessories, such as motor drives, different viewing systems and focusing screens, remote control devices, and flashguns dedicated to the camera that offer complete automation of exposure.

SLR SHUTTER SEQUENCE

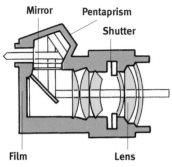

Mirror Pentaprism

Shutter

Film Lens

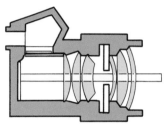

1 When viewing a subject, light passes through the lens and is reflected by a mirror, which lies in front of the film, into the pentaprism, which turns the image the right-way up for viewing.

2 When taking a photograph, the mirror moves up and the light hits the film. The speed of the shutter and the size of the aperture control how much light passes through the lens and reaches the film.

SINGLE LENS REFLEX CAMERA

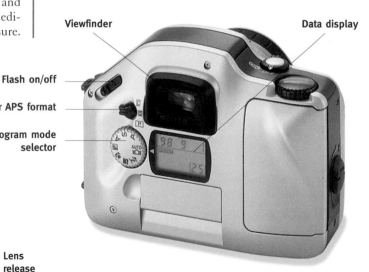

Shutter release

Nikon

PRONEA S

Interchangeable lens

AF

Auto/manual focus switch

Lens release button

Viewfinder

Data display

Flash on/off

Switch for APS format

Program mode selector

◄ ▲ This example of a modern APS single lens reflex camera has a range of features, including automatic focusing, various exposure modes, interchangeable lenses, and a data display.

Medium format SLRs While most SLRs take 35mm format film, a number, such as the Hasselblad, use the 120 format, giving images of 2¼x1¾in (6x4.5cm), 2¼x2¼in (6x6cm), or 2¼x2¾in (6x7cm). These cameras are often more expensive than their 35mm counterparts, but give better quality because of the larger film size. They have a somewhat different construction to 35mm models. The film may be held in an interchangeable back, so that rather than needing two camera bodies for black-and-white and color, for example, you can carry two backs, one for each type of film. In some models, the film backs allow you to use different frame sizes on the same 120 film, so a 2¼x2¾in (6x7cm) camera can also give 2¼x2¼in (6x6cm), 2¼x1¾in (6x4.5cm), and even 1¼in (35mm) images in some cases. Another difference is that the shutter in most models is situated within the lens, so that a second shutter is needed in the camera body. This makes the lenses very expensive.

OTHER CAMERA TYPES While the SLR and compact are by far the most popular cameras for most amateur photographers, there are several other specialist types that are worth considering for certain applications.

Panoramic cameras Panoramic cameras are direct vision cameras that usually take 120 roll film, although one recent model uses 35mm. These cameras produce long, wide images, such as 2¼x3½in (6x9cm) or even 2¼x4¾in (6x12cm). They are used primarily by landscape photographers, and are usually fitted with wide-angle lenses.

Technical cameras Large format "technical cameras," which usually take single sheets of film 5x4in (12.5x10cm) in size, are used most often by professionals, either in the studio or on location for subjects such as buildings. The front and rear components of the camera can be swung, tilted, or shifted in relation to each other, allowing a great deal of control over image shape and sharpness (for example, in correcting the convergence of verticals in architectural photography). Technical cameras are slow and cumbersome to use, but give superb results.

Twin lens reflex This old-fashioned looking camera is still used by many photographers, in particular wedding photographers, as well as students requiring the quality of 120 format film at a reasonable price. The camera has two identical lenses: one lens is used for viewing and focusing the image, the other lens is used for taking the actual picture. Like the compact, they suffer from parallax, caused by the fact that the viewing lens and taking lens are separate. However, they are very quiet in operation, and at least one make has a small range of interchangeable lenses.

▶ Medium format SLRs can be used with a number of detachable backs in which the film is held, including instant and 120 film holders.

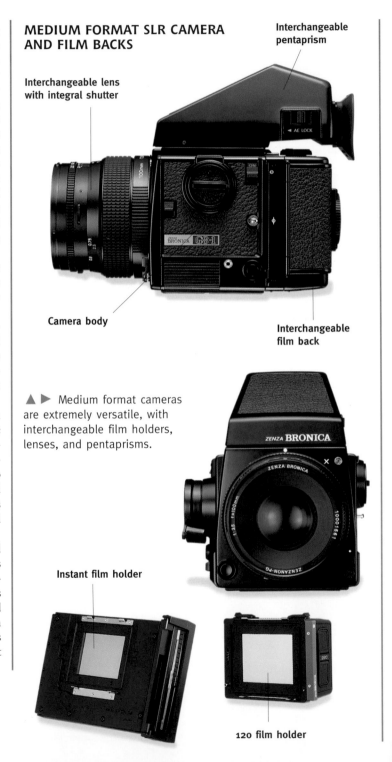

MEDIUM FORMAT SLR CAMERA AND FILM BACKS

Interchangeable pentaprism

Interchangeable lens with integral shutter

Camera body

Interchangeable film back

▲ ▶ Medium format cameras are extremely versatile, with interchangeable film holders, lenses, and pentaprisms.

Instant film holder

120 film holder

FEATURES TO LOOK FOR WITH SLR CAMERAS

The four most important features to look for with SLR cameras are a depth of field preview, flash synchronization socket, manual exposure facility, and a mirror lock.

Depth of field preview Depth of field, or zone of focus, is that area of the picture where the objects to be photographed are in sharp focus. A depth of field preview allows you to view the amount of depth of field that you will get in the final picture. It is carried out before you take the picture by "stopping the lens down" to the aperture that will apply when the picture is taken. The smaller the aperture setting (larger *f*-number), the greater will be the depth of field. Wide-angle lenses have greater depth of field than telephoto lenses. (See Exposure and Lenses.)

Flash synchronization socket Many cameras only have flash "hot shoes" (brackets into which a flash unit can be inserted and fired in synchronization with the camera shutter). These are situated on top of the pentaprism. However, it is often more convenient to have a synchronization socket into which you can plug external flashguns. If your camera does not have a socket, you can buy an adaptor that fits into the hot shoe and serves the same purpose.

Manual exposure facility In many cases, the camera's built-in automatic exposure system will produce adequate results. However, for some photographic purposes it is essential to be able to control the shutter speed and aperture independently of each other. The most convenient way of doing this is to have a manual exposure facility on the camera.

Mirror lock If you are going to use very long exposures, perhaps in excess of one second, it is possible that the movement of the mirror during the exposure cycle will cause vibrations, even with the camera mounted on a solid tripod. Some cameras offer the facility of locking the mirror before the exposure takes place, to minimize this possibility.

▶ Technical cameras allow the photographer to move the lens in relation to the film for correcting the shape of objects, or increasing the plane of sharpness.

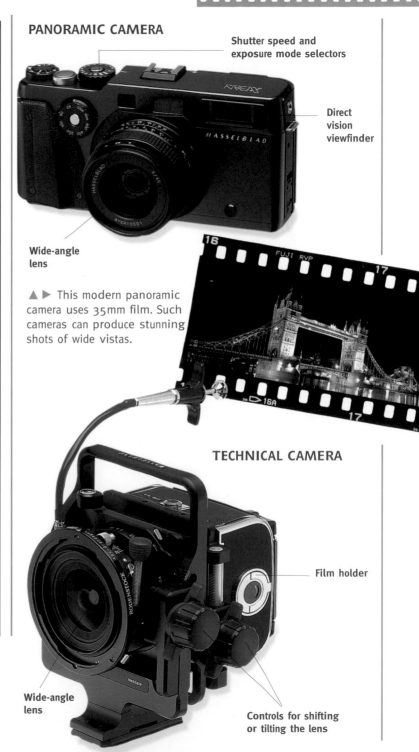

PANORAMIC CAMERA

Shutter speed and exposure mode selectors

Direct vision viewfinder

Wide-angle lens

▲ ▶ This modern panoramic camera uses 35mm film. Such cameras can produce stunning shots of wide vistas.

TECHNICAL CAMERA

Film holder

Wide-angle lens

Controls for shifting or tilting the lens

Instant cameras Instant cameras process the prints inside the camera, usually within a minute or so – the most well-known type is Polaroid. Instant cameras are very useful on social occasions such as parties, but are also employed extensively by people like the police and insurance investigators, who may require an instant record of a crime scene, for example. Professional photographers often use instant film in medium or large format cameras so that they can judge the exposure or lighting quality of a shot before shooting on conventional film.

Underwater cameras Several camera types, including direct vision compacts and SLRs, are available as underwater models, or with special underwater housings that allow you to take pictures in fresh- and seawater. They tend to be expensive, and have limited use on land. One or two manufacturers make waterproof cameras that can be used on land or underwater, but only to a very limited depth.

Disposable cameras Disposable cameras might be thought of as toys, but they are much cheaper than their conventional counterparts, and well worth considering for occasional use. They can give surprisingly good quality pictures. Several different types of disposable camera are available, including panoramic and underwater models.

INSTANT CAMERA

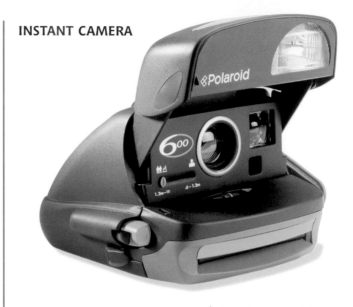

▲ This is a typical instant camera, producing prints in around 60 seconds. Some professional versions produce a high-quality negative.

DISPOSABLE CAMERA

▼ These are supplied pre-loaded with film. When the film has been exposed, the whole camera is taken into the processing laboratory. Various types are available, including panoramic and underwater versions.

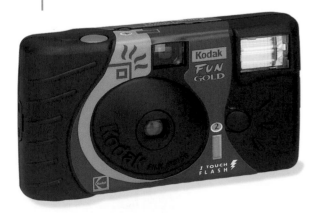

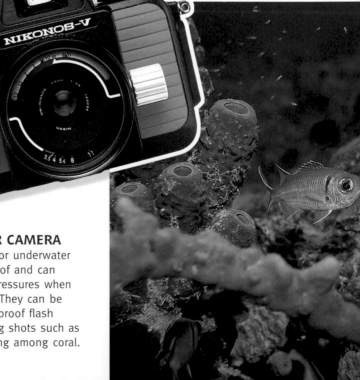

UNDERWATER CAMERA

▲ ▶ Cameras for underwater use are waterproof and can resist the high pressures when diving at depth. They can be fitted with waterproof flash units for stunning shots such as this fish swimming among coral.

BASIC CAMERA CARE Modern cameras are highly sophisticated devices, with high-quality optics and a mass of electronic circuitry. They must be kept clean, dry, and dust-free, so that they give the best possible results. A single grain of sand inside the camera body can ruin a whole film by scratching it along its length while the film is being transported through the camera. Every care should be taken, therefore, to prevent sand from getting into the camera, particularly on a beach. Keep the camera in a closed camera bag, perhaps even in a plastic bag, until you need to use it.

One of the greatest risks to cameras is salt water, and every precaution must be taken to avoid splashes. All external surfaces should be wiped down at the end of each day if you are working in a salty atmosphere. Lens surfaces are particularly vulnerable.

Keep a skylight filter screwed onto the front of the camera lens at all times (see Filters) in order to protect the main lens from dust and scratches. It is far cheaper to replace a skylight filter than it is to buy a new camera lens.

Cleaning the camera If the front lens element does require cleaning, blow away any dust with a blower brush or compressed air before using a special lens cleaning cloth or tissue. Try to do this as little as possible. When using a blower brush inside the camera, hold the camera upside-down, so that any dislodged dust falls out of rather than into the camera.

CLEANING YOUR CAMERA

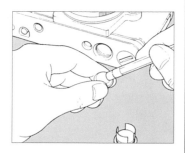

1 Use a soft brush, such as a toothbrush, to dislodge dirt from the external surfaces of your camera.

2 If the battery contacts need cleaning, use the eraser on the end of a pencil. Wipe the battery with a soft cloth afterwards, and try not to handle the battery with your fingers too much.

▲ PROTECTION FROM RAIN
Place your camera inside a plastic bag, held in place by rubber bands around the lens. Do not shoot through the plastic, but make a hole for the lens to see through.

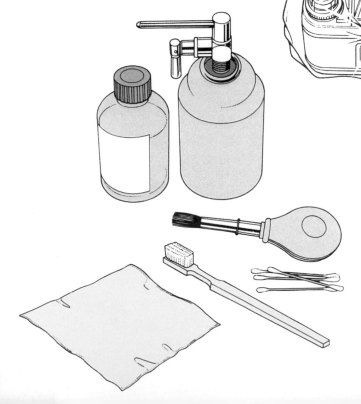

◄ BASIC CLEANING KIT
This should comprise a blower brush, cotton swabs, a lens cleaning tissue and lens cleaning fluid, a soft toothbrush, and perhaps a can of compressed air for removing dust from inaccessible corners.

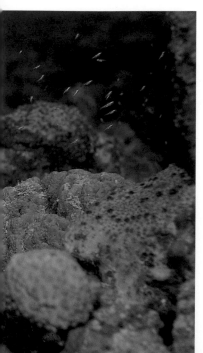

Camera Supports

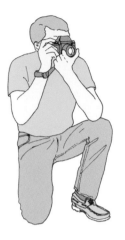

Spending a lot of money on a decent camera and lens, putting the best film into it, and taking great care over composition and lighting is useless if the final image is blurred as a result of camera shake. If possible, use a tripod or some other form of support.

Of course, there will be many subjects, such as candid shots of people, where you will have to hand-hold the camera. Camera shake is caused by many factors, but usually by trying to hand-hold a camera using long shutter speeds. A simple rule of thumb is that the slowest shutter speed you should use when hand-holding the camera is the reciprocal of the focal length of the lens you are using. For example, if you have a 135mm telephoto lens fitted to the camera, then the slowest shutter speed you should use is 1/135 second (1/125 is the nearest). Even then, good technique is essential.

HAND-HOLDING THE CAMERA Place one of your hands underneath the camera, bracing the elbow against your chest. Use your other hand to steady the camera, focus the lens, and gently depress the shutter release button. Try to remain as still as possible, and if you can, brace yourself against a wall, a tree, or some other vertical structure. If possible, kneel and brace your camera-supporting elbow against your knee.

TRIPODS The most common form of camera support is a tripod, and it is an unfortunate fact that the best tripods are the heaviest ones. They are clumsy, awkward things to carry, but they are an important aid to photography and should be a part of any photographer's armory. Not only will they lead to sharper pictures, they will also slow you down, forcing you to concentrate more on composition and exposure. There are many different types, each with a range of features. Don't be tempted by lightweight models, as they are not much help. Choose one that has two or three extensions to the legs, and a center column that can be raised or lowered. Some models can be set up in various positions, enabling you to photograph subjects in awkward places.

☞
Controlling the camera, pages 54–55

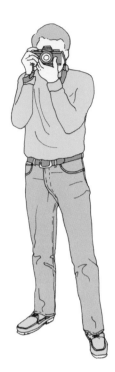

▲ HAND-HOLDING THE CAMERA
Try to reduce your own movement as much as possible – for example, by kneeling and supporting the camera on one knee, or by wedging your elbows against your chest.

USING A TRIPOD

WITHOUT TRIPOD The camera was hand-held for this shot, and a 1/15 second shutter speed used. The photograph shows distinct lack of sharpness due to camera shake.

WITH TRIPOD This shot was again taken at 1/15 second shutter speed, but this time with the camera firmly supported on a tripod and the shutter released via a cable release mechanism.

◀ BEAN BAG
A very useful form of camera support, and a remarkably effective one, is a cloth bag filled with dried beans, rice, or styrofoam beads. Bean bags are useful for taking pictures from vehicles – in game parks, for example.

▼ MONOPOD
Although only one-legged, monopods help to steady hand-held shots effectively. Their major advantages are that they are lighter than tripods and highly portable.

▼ Although there are many different types of tripod, certain features are common to them all.

MONOPODS For photographers whose subjects require them to keep moving, such as sports photographers, a monopod will be useful. While this only has a single leg, by bracing it against your body and using your legs as support, you can achieve remarkably sharp results. Many sports and nature photographers use monopods, as they are easy to carry around and quick to set up.

BEAN BAGS A very cheap form of camera support, one that can be used in many situations, is the bean bag. As the name implies, this is a bag (preferably cloth) filled with a granular substance such as dried beans, rice, or styrofoam balls. The bag is draped over a surface such as a car window ledge, and the lens of the camera pushed hard into it. Like the monopod, remarkably sharp pictures can be obtained even with long shutter speeds. Bean bags are often used by photographers on safari when shooting from vehicles. They have the advantage that they can be taken empty to a location and filled on site, saving weight during the journey.

CABLE RELEASE Even with the camera mounted on a sturdy tripod, it is well worth using a cable release to trigger the shutter. This will further reduce the risk of jarring the camera at the moment of exposure. Various types of cable release are available, from the simple cloth-covered manual version, to pneumatic bulb releases – which can operate at distances of up to 50–65ft (15–20m) – to highly sophisticated electronic infrared or wireless cable releases.

TRIPOD

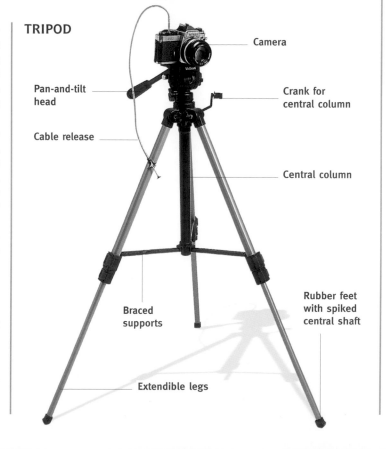

Camera

Pan-and-tilt head

Crank for central column

Cable release

Central column

Braced supports

Rubber feet with spiked central shaft

Extendible legs

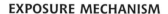

Exposure

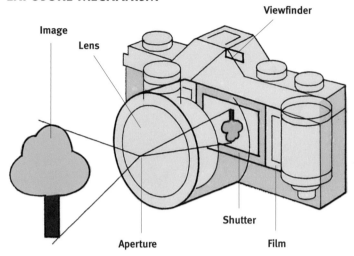

Exposure is the amount of light that the film receives. Cameras control the amount of light in two ways: by the amount of time the shutter is open; and by the size of the aperture in the lens, through which the light passes.

EXPOSURE MECHANISM

Viewfinder

Image

Lens

Shutter

Aperture

Film

▲ Light passes through the lens, which focuses the image onto the film. A large aperture allows more light to pass through the lens to the film; a small aperture allows less light to pass through. The shutter limits the length of time that light hits the film.

These two things work in combination so that the same exposure can be obtained from various combinations of shutter speed and aperture. Giving your film the correct exposure is thought of as being essential to a successful photograph, but the question is, what is the correct exposure for a scene? For most subjects, the answer is simple, and obvious in the picture. However, there will be many instances where the "correct" exposure is a matter of opinion and preference.

SHUTTER SPEEDS Most cameras have a typical range of shutter speeds: B, 1, 1/2, 1/4, 1/8, 1/15, 1/30, 1/60, 1/125, 1/250, 1/500, 1/1000 second, and so on (the B setting refers to "brief," where the shutter stays open for as long as the shutter release is pressed). However, some cameras will have more shutter speeds at either end of this scale, in some cases up to 30 seconds or more, or as short as 1/5000 second.

The scale is a halving, or doubling, scale. That is, each step is a half of the previous one, or twice the following one. The difference between each one is known as a "stop." For example, 1/60 allows twice as much light to reach the film as 1/125, and half as much as 1/30 second. The shutter speed will largely determine the amount of subject movement in an image. On the one hand – if you are photographing racing cars, for example – you will want the shutter to be open for as short a time as possible. On the other hand – if the subject is a still life, for instance – the shutter speed can be much longer, provided the camera does not move during the exposure.

☞
Cameras, pages 10–15
Film, pages 22–25

APERTURE A typical range of apertures is: ƒ2, 2.8, 4, 5.6, 8, 11, 16, 22, and 32. However, some lenses will have a range of apertures at either end of this scale. Once again, the scale is a halving and doubling scale, with the differences being referred to as "ƒ stops." The smaller the number, the larger the aperture. Therefore, ƒ8 will allow twice as much light to reach the film as ƒ11, and half as much as ƒ5.6. Photographers speak of "opening up a stop" and "stopping down" when moving up and down the aperture range.

The aperture used will determine the depth of field in an image. That is, it determines how much of the subject, both in front of and behind the main focal point, is sharp. For some subjects you will need a large amount of depth of field, and therefore a small aperture, while in other situations you will want to isolate the subject against an out-of-focus background and will use a wide aperture.

For a given light level, and given film, an exposure meter may indicate that 1/60 second at ƒ8 is the correct exposure. However, this combination may mean that there is not enough depth of field for the subject, and you may want to use ƒ16 instead. As ƒ16

APERTURE AND SHUTTER SPEED COMBINATIONS

Least ◄——————— DEPTH OF FIELD ————————► Greatest

f2 f2.8 f4 f5.6 f8 f11 f16

APERTURE

SHUTTER SPEED

1/1000 second 1/500 second 1/250 second 1/125 second 1/60 second 1/30 second 1/15 second

Same overall exposure level

Least ◄——————— MOTION BLUR ————————► Greatest

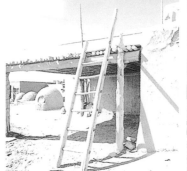

1/30 second at f5.6

1/30 second at f11

1/30 second at f22

1/125 second at f5.6

is two stops smaller than f8, in order to allow the same amount of light to reach the film, you will need to use a shutter speed two stops slower – 1/15 second.

FILM SPEED A further factor determining exposure is that of film speed. Films are classified as slow, medium, fast, and ultra-fast. What this means is that a slow film requires more light to expose it correctly than a fast film does. The numbers used to describe film speeds – like shutter speeds and apertures – are on a doubling and halving scale, so that a 50 ISO film requires twice as much light as a 100 ISO to get the same exposure.

FILM SPEED						
Slow		**Medium**		**Fast**		**Ultra-fast**
25	50	100	200	400	800	1600 3200 ISO*

Slow films require most light; ultra-fast films require least light
** International Standards Organization*

ESTIMATING LIGHT For many types of photography, it is possible to estimate the amount of light required with a high degree of success. One rule of thumb often quoted is the "sunny ƒ16 rule." This says that the exposure required for a bright sunny day is the reciprocal of (one over) the film speed at ƒ16. So, with a 100 ISO film it would be 1/125 at ƒ16 (1/125 second is the nearest shutter speed to 1/100). Keeping the shutter speed at 1/125, the aperture would increase to ƒ11 with light cloud cover, to ƒ8 with medium cloud cover, and so on as the level of sunlight decreases. This is the guide given on the box that films are sold in (see below).

MEASURING EXPOSURE All modern 35mm SLR cameras, and many medium format SLRs, have a light meter situated behind the lens, which is used to figure out the amount of exposure a subject requires using a given film speed. The light meter is simply a light-sensitive cell that measures the amount of light available in a subject. The amount of light is registered on a gauge, again using a halving and doubling scale – that is, 5 means there is twice as much light as at level 4, and half as much light as at level 6, for example.

The film speed must be set correctly in order to obtain the correct exposure reading. When the dial is set to the appropriate light level, a range of ƒ-stop and shutter speed combinations is shown, all of which will produce the same exposure. An ideal exposure setting may be given in a digital display. Various hand-held light meters are available that are used separately from the camera.

Spot metering The meter takes a light reading from just a small part of the subject, known as a spot. It is very important that the spot you choose is the tone you wish to be exposed correctly.

Center-weighted metering The meter takes readings from all parts of the subject, but places most emphasis on the central area.

Matrix metering With this method, the meter takes several readings from across the frame and compares them with a database stored in the system's memory.

SUNNY ƒ16 RULE				
Bright sun	Hazy sun	Weak sun	Sun and cloud	Dull
ƒ16	ƒ11	ƒ8	ƒ5.6	ƒ4
ISO 100 FILM				

USING EXPOSURE METERING SYSTEMS

SPOT METERING This method of metering takes the light reading from a very small area of the image. It is very useful for metering subjects such as portraits, where achieving accurate skin tone is important.

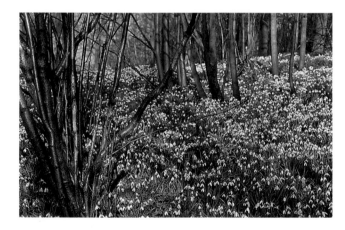

▲ DAPPLED LIGHT
Dappled light on a carpet of pure white flowers is particularly difficult to expose correctly. Center-weighted metering was used here.

CENTER-WEIGHTED METERING This method is based on the way in which many photographers frame their images, with the main subject in the center of the frame and a horizon near the top of the image.

MATRIX METERING This takes readings from different parts of the image, and compares the resulting pattern with a database of patterns stored in the system's memory. The exposure is adjusted to give the best result for that pattern.

EXPOSURE MODES Most modern cameras, particularly SLRs, have a variety of modes for adjusting the exposure.

Aperture priority The aperture priority allows you to set the aperture manually on the lens; the camera then automatically sets the correct shutter speed. Use this mode if you need to have control over depth of field.

Shutter priority This is the opposite of aperture priority. You set the shutter speed to determine the amount of subject movement, and the camera automatically sets the aperture.

Program mode In program mode the camera produces an "optimum" combination for the lighting conditions. You have no control over the shutter or aperture. Some program modes give priority to the shutter speed when using long telephoto lenses, and you can buy extra program cards for some cameras. For example, there are program cards that instruct the camera to give priority to aperture.

Manual mode In manual mode you are able to control both shutter speed and aperture independently, in conjunction with the meter inside the camera. If you are using a camera for creative photography, you should have a manual facility.

EXPOSURE COMPENSATION CONTROL Camera meters assume that you are photographing subjects under average light conditions, but there are many instances when you will want to alter the exposure given by a camera meter. Backlit subjects, very bright or very dark subjects, or pictures in which the main subject occupies a very small part of the overall scene can fool the camera meter into giving false readings, and the film may need more or less exposure than the meter has allowed.

The main thing to remember is to expose for the most important part of the subject. Most SLR cameras and many compacts have an exposure compensation control for giving increments of a half or whole stop more or less exposure to a subject. If you are not sure how much you should compensate, it is well worth bracketing your exposures. That is, doing a range of shots at different exposures and choosing the best one afterwards when producing prints.

◀ BRACKETING EXPOSURES
This image has been bracketed in half-stop increments to ensure that the required result is achieved.

Film

Sensitized photographic film (or a glass plate) is the means by which images are recorded in a camera, with the exception of video and digital models. There are many different varieties of film, but they all have the same basic principles in common.

The major constituents of a film are silver halide and gelatin, which are mixed together as a warm liquid to form an emulsion. The emulsion is coated onto rolls of plastic material, which, when cool, is cut to size ready for the camera. The silver halide crystals are sensitive to light, and their chemical structure is altered once they have been exposed. Film is divided into two main categories: black-and-white, and color.

BLACK-AND-WHITE FILM Black-and-white film records the actual intensity of light as shades of gray. The developing stage of the photographic process turns the silver halide crystals that have been exposed to light into minute grains of metallic silver. Light from a bright area of the subject will affect more silver halide crystals than light from a dark area. When these are developed, they are converted to grains of metallic silver, forming a dark area on the negative. When the film is printed to a positive, it becomes a light area again.

COLOR FILM Color film is more complex, and consists of three layers of light-sensitive emulsion, with each layer sensitive to a particular color – red, green, or blue. During exposure, blue light from a subject will affect the silver halide crystals in the blue-sensitive layer of the film, and so on.

During development, a colored dye forms in the relevant layer of a complementary, or opposite, color to the layer in which it is formed – that is, yellow dye forms in the blue-sensitive layer, magenta dye in the green-sensitive layer, and cyan dye in the red-sensitive layer. The silver crystals are then bleached out, leaving just the three complementary colors. Various combinations of these colors produce all the other colors in the photograph.

When a color negative is printed, a similar process takes place in the three layers of the

☞
Exposure, pages 18–21

BLACK-AND-WHITE FILM

1 Film base
2 Silver halide crystals
3 Gelatin emulsion
4 Layers of adhesive
5 Scratch-resistant coating
6 Antihalation coating (prevents light from passing through film base to emulsion)

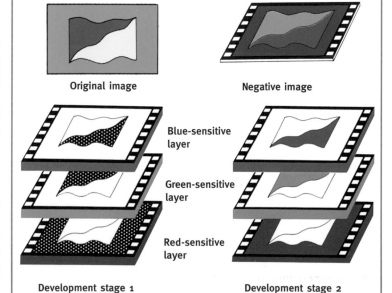

▶ Simplified cross-section of a black-and-white film, showing the relative thickness of the layers.

COLOR NEGATIVE FILM

Original image

Negative image

Blue-sensitive layer

Green-sensitive layer

Red-sensitive layer

Development stage 1

Development stage 2

▲ The colors produced in a negative are complementary, or opposite, to those in the original subject. During development, silver crystals form in the relevant layer (stage 1), then colored dyes are "coupled" with the silver, and the silver is bleached away to leave just the color (stage 2).

COLOR TRANSPARENCY FILM

Original image

Transparency image

Blue-sensitive layer

Green-sensitive layer

Red-sensitive layer

Development stage 1

Development stage 2

Development stage 3

▲ The colors produced in a transparency are the same as those in the original subject. First, the film is processed using a monochrome developer that forms a negative image in the film (stage 1). A reversal stage, using a color developer, then "fogs" the previously unexposed silver crystals and "couples" the already exposed silver with colored dyes (stage 2). The silver is then bleached away, leaving just the transparent dyes and a positive image (stage 3).

USING DIFFERENT FILM SPEEDS

50 ISO FILM This highly magnified image shows the fine grain of this slow film, enabling fine definition to be recorded.

400 ISO FILM The grain in this fast film is much more apparent, and the detail of the lettering starts to be lost.

3200 ISO FILM Very little detail can be seen here, but some photographers use ultra-fast film such as this for pictorial effect.

printing paper, whereby the complementary colors of those in the negative form in the relevant layer of the paper. This therefore reverses the colors on the negative back into the colors of the original image.

Color transparency film goes through a reversal process during film processing, so that the image on the film is a positive – that is, the colors of the original image are the same as the colors on the processed film.

FILM SPEED Film is available in different speeds, or sensitivities. These are categorized as slow, medium, fast, and ultra-fast, and given an ISO (International Standards Organization) rating.

In general, a fast film produces results that have a coarser, more visible grain structure than a slow film, and cannot record such fine detail. Also, the saturation of the colors on a fast color film will be lower than on a slow color film. However, a fast film can be used in lower light levels.

FILM SPEED AND GRAIN CHARACTERISTICS

Slow	Medium	Fast	Ultra-fast
25 50	100 200	400 800	1600 3200 ISO*
Very fine grain	Fine grain	Coarse grain	Very coarse grain

** International Standards Organization*

USING UPRATING AND DOWNRATING TECHNIQUES

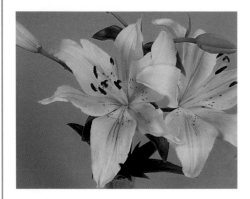

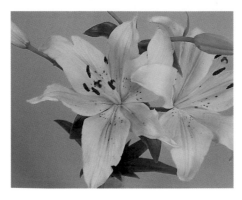

NORMAL It is possible to uprate or downrate color transparency film during processing. This is 100 ISO film exposed and processed as normal for 100 ISO.

DOWNRATING Here, 100 ISO film has been shot as if it were 50 ISO and downrated during processing. It gives similar results, but with slightly more contrast.

UPRATING Here, the film has been shot as 200 ISO and uprated during processing. There is a slight increase in grain size, and a small color shift in the background.

UPRATING/DOWNRATING FILM The sensitivity of film (with the exception of color negative film) can be altered, to some extent, during processing. If you find that you do not have the correct film speed for your requirements, you can use exposure settings suitable for a faster or slower film than the one you are actually using and compensate for the film's under- or overexposure at the processing stage. Increasing the development time is known as "pushing" or "uprating" the film (increasing its speed); decreasing the development time is known as "pulling" or "downrating" the film (decreasing its speed). Most modern cameras automatically set the film speed using the DX coding system (a checkerboard pattern on film cassettes that is read by sensors inside the camera), so it is necessary to override this by setting under- or overexposure settings manually on the camera. Alternatively, there are special stickers that can be placed over the DX markings on the cassette to "convert" the film to a new speed.

CHROMOGENIC FILMS One particular group of black-and-white films, known as "chromogenic" emulsions, can be processed in color negative processing chemicals, which means that you can take them to your local minilab for developing. The lab will produce conventional black-and-white prints; it can also produce excellent sepia-toned prints from the negatives.

FILM FORMATS Film is classified by its size. The most frequently used types are 35mm and 120 (medium format) roll film, and 5x4in (12.5x10cm) sheet film. 35mm is the most common type and is used in compact and SLR cameras. 120 roll and 5x4in (12.5x10cm) sheet film are used for the medium format cameras owned by professionals, with the latter producing different negative sizes from the same film.

▶ DX CODING SYSTEM
Most modern 35mm films have a sequence of silver bars on the outside of the cassette, which conveys information about the speed of the film to the camera.

120 FILM FORMATS

▲ Different formats can be achieved from 120 roll film – which is 2¼in (6cm) wide – by altering the length of the frame in the camera.

1 2¼x1³/₄in (6x4.5cm)
2 2¼x2¼in (6x6cm)
3 2¼x2³/₄in (6x7cm)
4 2¼x3½in (6x9cm)

ADVANCED PHOTOGRAPHIC SYSTEM (APS) FORMATS

◄ The following formats are achieved by selecting different areas of the negative when printing:

1 **Classic prints (4x6in/10x15cm, 3:2 ratio)**
2 **HDTV (High Definition Television) prints (4x7in/ 10x18cm, 16:9 ratio)**
3 **Panoramic prints (4x11in/ 10x28cm, 3:1 ratio)**

▼ APS PROCESSING
APS gives a choice of three different formats from the same negative. An index print of all the images from the roll is supplied for reference when the prints are processed.

ADVANCED PHOTOGRAPHIC SYSTEM (APS) The film width is slightly smaller than 35mm and comes in automatic loading cassettes. The film is sent to a lab for processing, and returned inside the cassette, so that you never handle the negatives and risk damaging them. Cameras have the facility of giving three picture formats. Information relating to the picture, such as date, exposure, or use of flash, is recorded digitally on a transparent magnetic layer on the surface of the film. An index sheet of "thumbnail-sized" contact prints is supplied for reference purposes when the film is processed.

INSTANT FILM Polaroid is an "instant" material that carries its own developing chemicals. Some instant films produce a re-usable negative. Instant film can be used in special Polaroid cameras and in certain other manufacturers' cameras. Many professionals use Polaroid to evaluate lighting and exposure before exposing conventional film.

INFRARED FILM There are two infrared-sensitive films, a black-and-white and a color version. The black-and-white must be used in conjunction with a special filter that absorbs daylight, allowing just the infrared to reach the film. It is very grainy. The color version is known as "false color" film, and produces interesting effects.

► MONOCHROME INFRARED FILM
Images shot with black-and-white infrared film have a coarse grain and a great deal of contrast, producing images with a highly distinctive character. Many landscape photographers use this film for pictorial effects.

Lenses

Single lens reflex cameras (SLRs) have the facility of interchangeable lenses, and many compacts have variable focal length, or zoom lenses. These features will add greatly to your ability to photograph different subjects.

For example, the standard or normal lens for a particular film format is one that produces an image that approximates the field of view of the human eye. When you change the lens, you are able to include more or less of the subject without altering the position of your camera.

FOCAL LENGTH The focal length of a lens is the distance from the center of the lens to the film plane when the lens is set at infinity. It is measured in millimeters. The figure is derived from the length of the diagonal of the negative size. For example, for 35mm film the focal length of a standard lens is approximately 50mm, and for 2¼x2¼in (6x6cm) film it is 75mm. Lenses with a focal length shorter than standard are known as wide-angle, because they give a wider angle of view. Lenses with a longer focal length are known as telephoto or long-focus lenses.

GENERAL-PURPOSE LENS SET For general-purpose photography, you will probably require a lens set consisting of a wide-angle lens such as a 28mm, a standard lens of 50mm, a medium telephoto lens such as a 100mm, and a longer telephoto lens, perhaps a 200 or 300mm.

Wide-angle and telephoto lenses Typical examples for 35mm wide-angle lens lengths are: 15mm, 20mm, 28mm, and 35mm. Typical examples for telephoto lens lengths are: 135mm, 200mm, 300mm, and 500mm. Lenses of fixed focal length are known as prime lenses, and are usually optically superior to zoom lenses.

Zoom lenses Zoom lenses have a variable focal length, and can be zoomed to give precisely the composition required. They can be found in a number of different ranges, such as 35–70mm, 28–200mm, 80–210mm, and 100–300mm.

☞
Cameras, pages 10–15
Exposure, pages 18–21
Film, pages 22–25

LENS CONSTRUCTION

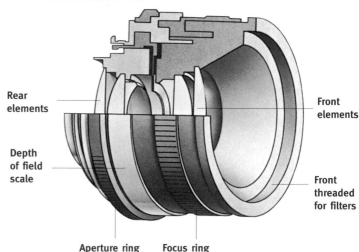

Rear elements

Depth of field scale

Front elements

Front threaded for filters

Aperture ring Focus ring

▲ Camera lenses – also known as compound lenses – are constructed from a number of glass elements, often made from different materials.

STANDARD LENS FOCAL LENGTH

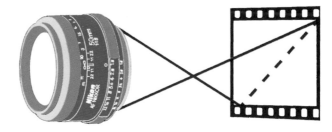

▲ The focal length for a "standard" lens is approximately the length of the diagonal through the film. With 35mm film, therefore, the standard lens is 50mm.

Zoom lenses are excellent for the location photographer because they cover the focal lengths of several prime lenses. They enable precise framing and cropping of the subject. You can obtain special effects by zooming the lens during a long exposure. Their main disadvantage is that their weight is that of the longest focal length in the range. A prime 100mm lens is relatively small and light, but if you have a 100–300mm zoom, then the 100mm will be the weight of the 300.

ANGLES OF VIEW WITH DIFFERENT FOCAL LENGTHS

▶ As focal length increases, the angle of view becomes progressively narrower, while at the same time, magnification of the subject increases. With a 20mm lens, the angle of view is 94°, while with a 400mm lens, it is reduced to a mere 6°. Provided the viewpoint remains the same, the perspective will be unaltered.

STANDARD LENS

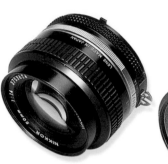

▲ The standard lens is the focal length most frequently supplied with the camera body at the time of purchase.

MEDIUM TELEPHOTO ZOOM

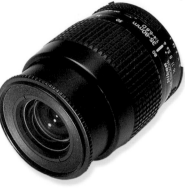

▲ Zoom lenses, typically with focal lengths of 35–80mm, have become popular in recent years, bridging the gap from wide-angle to telephoto.

LONG TELEPHOTO ZOOM

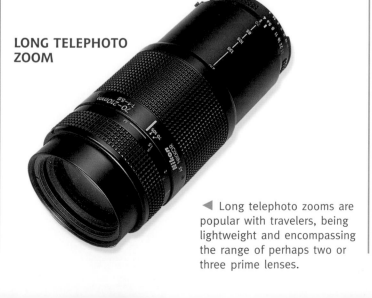

◀ Long telephoto zooms are popular with travelers, being lightweight and encompassing the range of perhaps two or three prime lenses.

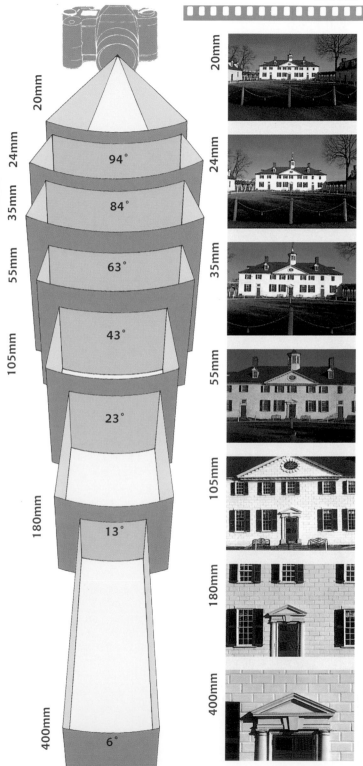

20mm — 94°
24mm — 84°
35mm — 63°
55mm — 43°
105mm — 23°
180mm — 13°
400mm — 6°

USING LENSES WITH DIFFERENT FOCAL LENGTHS

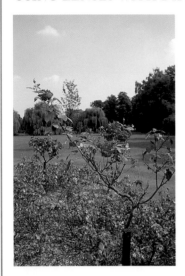

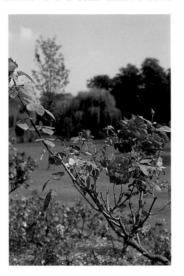

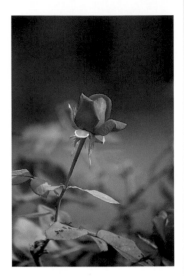

28MM LENS Try shooting a subject from the same position using different lenses. This lens gives a view of the whole scene.

50MM LENS With a standard lens, the red rose begins to stand out as the main subject and point of focus in the image.

100MM LENS The background is far less distracting in this image, allowing the viewer to concentrate on the rose.

200MM LENS The background is now well out of focus, effectively isolating the rose and producing a strong composition.

CHOOSING A FOCAL LENGTH Different focal length lenses have different angles of view, but the choice of which length to use for a particular purpose will depend on other factors as well. Working distance, or the distance between the camera and the subject, is important. When you halve the focal length, you and your camera will be twice as near to the subject, but still have the same size image. For example, if you are 32ft (10m) away from a subject with a 200mm lens, then by switching to a 100mm lens, and keeping the same image size, you will ostensibly be only 16ft (5m) away. This is useful when photographing subjects such as birds or sporting events.

LENS SPEED The speed of a lens is the maximum aperture size of the lens (see Exposure). For standard lenses, for example, this may be $f2.8$ or $f2$, and for telephoto lenses, $f4$ or $f5.6$. Some lenses, in particular standard 50mm lenses, might have a very large maximum aperture, such as $f1.2$ or $f1.4$. Having a large maximum aperture means that you can use a relatively fast shutter speed in low light levels. For example, a lens with a maximum aperture of $f4$ may require a shutter speed of 1/30 second. If the lens had a maximum aperture of $f2.8$, then you could use 1/60 second shutter speed instead. Sports photographers in particular prefer lenses with a large maximum aperture. They are usually far more expensive than the same lens with a smaller aperture; the less expensive one is fine for most purposes.

HOW FOCAL LENGTH CONTROLS IMAGE SIZE

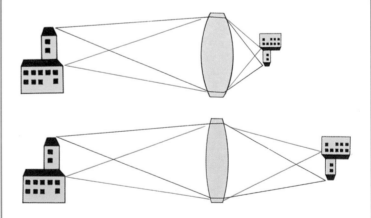

▲ When viewed from the same position, a subject photographed with a short focal length lens (top) will appear smaller than when shot with a long focal length lens (bottom). However, the image taken with the short focal length lens will have a wider angle of view.

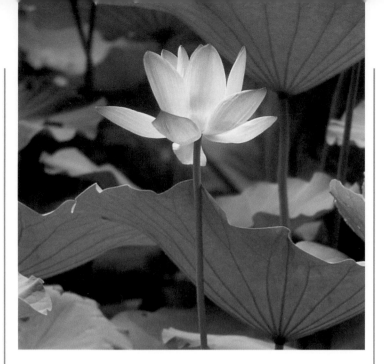

▲ DEPTH OF FIELD
This lotus flower has been isolated by the use of a long telephoto lens, making the flower stand out from its background. The camera was supported on a firm tripod to ensure that the fine detail in the flower and surrounding leaves was well-resolved.

DEPTH OF FIELD Depth of field is the distance in front of, and behind, the main point of focus that is acceptably sharp. It can be increased or decreased by changing the aperture. Usually, the more you magnify a subject, the smaller the depth of field becomes. The success of many photographs depends on whether they have a large or shallow depth of field. A shallow depth of field can allow you to concentrate on a subject such as a flower set against a background that is completely out of focus, while with other subjects, such as a still life, you may want every part of the picture to be sharp. Control over depth of field is therefore very important, and being able to preview the depth of field before taking a picture is extremely useful. Many lenses have a depth of field scale engraved on the lens barrel, but this is not as good as being able to see the effect through the viewfinder with a depth of field preview lever (see Cameras).

Depth of field is controlled by the aperture, magnification of the subject, and the degree of final enlargement. A smaller aperture or *f* stop will lead to a greater depth of field. You might like to try a useful experiment by setting up several objects in a line and photographing them at different apertures to see the effect. Focus on the middle object. The depth of field, or zone of focus, usually extends from one-third the distance in front of an object to two-thirds behind it.

APERTURE AND FOCAL LENGTH

▼ For any given aperture (below), the depth of field of a standard lens is less than that of a wide-angle lens but greater than that of a telephoto. When focal length and aperture are constant (bottom), a distant subject will have more depth of field than one close to the camera.

Changing the lens

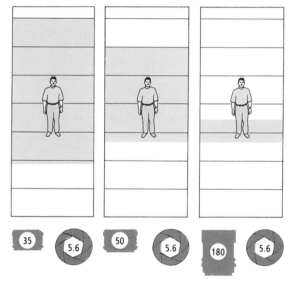

Changing the distance from the subject

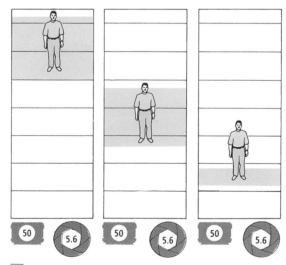

☐ Tinted area = depth of field

OTHER LENS TYPES There are a number of other lenses that may be useful in particular situations in addition to the general-purpose lens set already suggested.

Mirror lenses One major disadvantage of long telephoto lenses is their length and bulk. Mirror lenses were developed to overcome this by "folding" up the optics, and using curved mirrors as well as lenses to reduce the physical length and weight of the lens. A 500mm telephoto lens may be 12in (30cm) or more in length, whereas a 500mm mirror lens may be only 5in (12cm) or so, although it will be wider. Their main disadvantage is that they have a fixed aperture, usually ƒ8 or ƒ11, meaning that exposure must be adjusted by the shutter speed only, or by using neutral density filters, which are usually built into the lens. Also, out-of-focus highlights are recorded as unsightly and distinctive donut-shaped rings rather than attractive blurs.

Macro lenses A macro lens is one that has been designed to focus more closely to the subject than normal lenses. A variety of focal lengths are available, including 55mm, 105mm, and 200mm. Various zoom lenses offer a macro facility as well. Macro lenses can also be used as standard or normal lenses for distant subjects. They are usually more expensive than conventional lenses, but if you intend to do a reasonable amount of close-ups, they are well worth the investment.

Perspective control (PC) lenses These are usually wide-angle lenses, typically 28 or 35mm, with a facility for shifting the lens vertically or horizontally, relative to the film. This mimics some of the camera movements that are available on professional technical cameras, and enables the photographer to shoot subjects such as tall buildings without the verticals converging. Some models are also available with an additional swing facility for controlling the sharpness of an image. However, they tend to be very expensive and have a very specialist use.

MACRO LENS

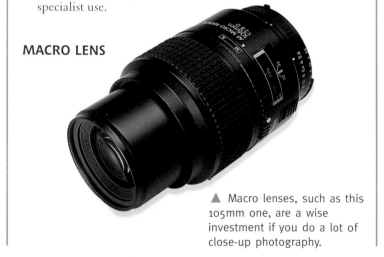

▲ Macro lenses, such as this 105mm one, are a wise investment if you do a lot of close-up photography.

▲ MACRO CLOSE-UP
This orchid was shot with a 105mm macro lens, which is able to resolve very fine detail when used close to the subject. In this case, the magnification was half life-size on the transparency.

Fisheye lenses This is a very short focal length lens of 6, 8, or 10mm. It gives an extremely wide-angle view. In the case of the shortest ones, perhaps 6mm, the fisheye gives an angle of view of up to 220°, so that it actually sees behind itself. Some fisheyes give a full frame view on the film, while others give a circular picture. They are usually very expensive, and have a limited use.

AUTOFOCUS SYSTEMS Most camera systems and their associated lenses are now autofocus, meaning that they automatically focus on the main subject. This is an excellent facility for people who photograph moving subjects, such as sport and wildlife photographers, but is of questionable value for still life subjects.

In the early days of autofocus, systems were rather slow, but today it is possible to keep track of fast-moving objects – such as a bird or car coming toward you – and keep it in focus all the time. The autofocus system usually works from the central area of the frame. If the subject that you want to focus on is not in the center of the frame, this may cause a problem. Many cameras have an autofocus lock, whereby you point the camera at your subject, lock the focus, and then compose the picture again. Autofocus systems have problems with some subjects, such as spiders' webs and subjects behind glass, as in these cases the system does not know what to focus on. Under these circumstances, it is probably worth switching to manual focus mode.

It is worth noting that many professional cameras do not have autofocus facilities, and while autofocus is a great facility to have, it is not essential for most subjects.

USING A LENS HOOD

LENS HOOD

WITHOUT LENS HOOD This image is badly degraded by flare, stray light that has struck the front of the lens and been reflected onto the film, causing lack of contrast.

WITH LENS HOOD Here, the image has been greatly improved by the use of a lens hood, which has prevented most of the stray light from striking the front of the lens.

▲ Lens hoods are available in a variety of forms, including this variable bellows type, which can be adjusted to suit various focal length lenses.

LENS HOOD Lens hoods are essential accessories for lenses. Their main purpose is to prevent flare, which is a degradation of the image that occurs when unwanted light is scattered within the lens. It leads to lack of contrast, although in extreme cases the flare will show up as a bright area in the picture, often with a line of hexagonal reflections of the iris diaphragm radiating from it. The lens hood is designed to shield the front surface of the lens from unwanted light, in the same way that we shade our eyes when looking at a bright landscape. Try it when you are looking toward the sun; the colors become noticeably more saturated.

To be effective, a lens hood must be the right depth and angle for your lenses. One designed for a wide-angle lens will be no use on a long telephoto lens, and vice versa. Most manufacturers make special hoods for their lenses, and it is well worth investing in this. Many telephotos have built-in hoods. In addition, some filter systems have hoods that fit in front of the filters.

BELLOWS Bellows units are used primarily for high-power macro photography, and are a variable extension inserted between the camera lens and camera body. They tend to be rather unwieldy, and are used mainly in the studio where they can be solidly mounted on a tripod.

BELLOWS

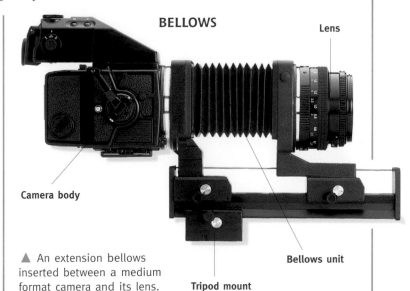

Lens

Camera body

Bellows unit

Tripod mount

▲ An extension bellows inserted between a medium format camera and its lens.

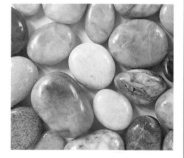

Light Sources

Photography is all about the recording of light reflected from or passing through subjects, and the quality, quantity, and color of light are all vitally important for a successful photograph. Most photography uses the visible part of the electromagnetic spectrum, with colors ranging from violet and blue to orange and red.

Some specialist types of photography can record the ultraviolet and infrared areas of the spectrum for scientific, technical, or creative purposes (see Film). Four main light sources are used for most photography: daylight, flash, tungsten, and fluorescent.

DAYLIGHT This is easily the best light condition for photography – it is free, natural, and has a huge diversity of qualities. However, it is this last point that also makes daylight unreliable as a light source for photography. The quality, quantity, and color of daylight will vary throughout the day and with different weather conditions. A scene that one minute is dull and uninteresting can be transformed into a magical image with the appearance of the sun or rain clouds.

ELECTRONIC FLASH The electronic flash is probably the most convenient, versatile, and least expensive of the various types of artificial lighting available. It comes in a wide variety of sizes, from small units built in to cameras to larger units designed for studio use. The flash is produced by creating an intense, short-duration spark within a glass tube. The tube is capable of producing thousands of flashes, so the only running costs for small flash units are batteries, and mains electricity for studio versions. The color temperature (see page 35) of the flash is the same as average noon daylight, which is 5,500K, so you can use a flash with daylight-balanced color film without color correction.

Even if you are going to do most of your photography outside, it is worth having at least one small flash unit to act as a fill-in to the daylight.

Built-in flashes Many modern cameras have built-in flash units,

☞

Cameras, pages 10–15
Film, pages 22–25
Filters, pages 58–63

ELECTROMAGNETIC SPECTRUM

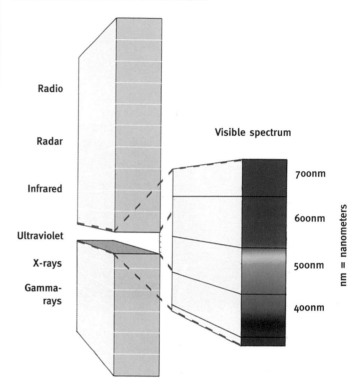

Radio

Radar

Infrared

Ultraviolet

X-rays

Gamma-rays

Visible spectrum

700nm

600nm

500nm

400nm

nm = nanometers

▲ Light wavelengths are measured in nanometers. The human eye can see the colors within the 400–700nm range.

USING DAYLIGHT AND ELECTRONIC FLASH

DAYLIGHT This was shot with overcast daylight on daylight-balanced film. Notice the rather cold appearance.

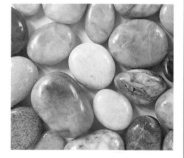

FLASH When the same group of pebbles is shot with electronic flash, it results in a warmer, more natural appearance.

usually on or very close to the lens axis. Their disadvantage is that they can produce flat, uninteresting lighting, or a "red-eye" effect when photographing people (it occurs as a result of light reflecting off the blood vessels in the retina on the back of the eye, and recording on the film). Try to get a flash unit that you can operate away from the camera by means of an extension lead. This will allow a much greater range of flash positions.

Studio flash units Studio flash units can be fitted with a wide variety of accessories, such as umbrellas that give a soft, even light, and snoots (inverted cones), which give a harsh, spotlit effect. Most studio units have built-in modeling lights, which are continuous tungsten bulbs that allow you to preview the lighting effect before taking a picture.

A studio flash needs to be linked to the camera with a flash synchronization cable. If you have a camera without a synchronization socket, you will need to buy an adaptor that fits into the hot shoe on top of the pentaprism (see Cameras). If you are using more than one flash, you can link them with slave cells. These are small electronic devices that fit into the second and subsequent flashes. The light from the first flash is seen by the slave, which then triggers the flash that it is plugged into. There is virtually no delay, and the system greatly reduces the need for trailing wires around the studio floor.

Flash accessories Various designs of umbrella can be used to diffuse or soften the light from electronic flash guns. They give a soft, even light, and are convenient since they can be folded for storage. Other accessories for electronic flash include soft boxes, which mimic the diffuse light coming through a window and are sometimes known as "window lights."

DIFFUSING ELECTRONIC FLASH

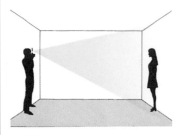

1 Direct electronic flash will result in harsh shadows and high-contrast lighting.

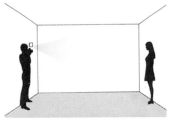

2 The flash gun can be diffused with a layer of tracing paper, white plastic, or white cloth. The lighting will appear rather flat, but may be suitable for some subjects, such as female portraits.

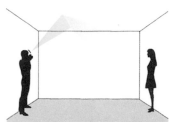

3 Bouncing the light off a white ceiling is another way to diffuse the light. It will produce more of a "top lighting" effect, similar to sunlight.

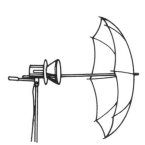
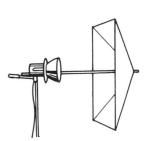
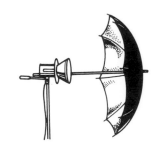

◄▲ FLASH UMBRELLAS These can be translucent, so that the flash is diffused as it passes through the material, or plain white or silver, for reflecting the light. Different shapes produce slightly different results.

FLASH SAFETY

Electronic flashes work by discharging a high-voltage capacitor through a glass tube to produce an intense spark, so a few basic safety rules should be adhered to when handling them.

■ If the flash fails to operate, don't open it and poke around inside. The capacitors store large amounts of electricity, which could be lethal. Get a qualified electrician to look at the unit.

■ Never operate the unit with wet hands.

■ Never push screwdrivers into the synchronization socket to test it.

■ Many flashes have external fuses that can be changed safely; otherwise, get a qualified electrician to do so.

USING TUNGSTEN AND FLUORESCENT LIGHT

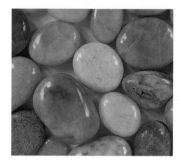

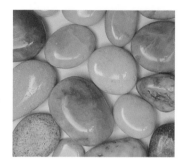

TUNGSTEN This was shot on daylight-balanced film with tungsten light, resulting in an overall orange cast.

FLUORESCENT It is best to avoid this type of light, as it is difficult to compensate for the poor colors that it produces.

TUNGSTEN LIGHTING Before the arrival of studio flash lighting, most studio photographers worked under tungsten lighting. Today, the system is by no means obsolete, and is used by many professionals. In order to give the required amounts of light, for example 500 or 1000 watts, the units need to be large, and they are therefore quite cumbersome. They also generate a large amount of heat, which makes it very uncomfortable for models, and unsuitable for some subjects, such as animals and food. Another major problem with tungsten lighting is that the color temperature changes with voltage fluctuations, so if you require these lights for accurate color rendition, they need to be used with care. However, tungsten lighting does have an important advantage over other lighting systems: it is highly controllable.

There are three basic types of tungsten light: the flood lamp, the spot lamp, and the soft light. The flood lamp does exactly what its name implies – it gives a broad flood of light to an area. The spot can be focused along a narrow beam of light. The soft lamp is usually a large dish with a reflective cover over the bulb. This results in a very soft, even light, excellent for portraiture. Photofloods are a relatively inexpensive form of tungsten bulb and are available from photographic dealers. They have a fairly short life, but can be fitted into a variety of reflectors.

FLUORESCENT LIGHTS As a rule you should avoid using fluorescent lights for photography, although there may be occasions when you are forced to work with them because they are a fixture in the room in which you are photographing. Most fluorescent lights do not emit light from all parts of the electromagnetic spectrum, which causes colorcasts on the film. These are very difficult, and sometimes impossible, to correct. If you do have to use fluorescent lights, try to make sure that all tubes are of the same type and age. Film manufacturers publish recommended

TUNGSTEN LIGHTS

▶ **SPOTLIGHT**
Tungsten lights are available in a variety of shapes and sizes. Many photographers use tungsten for large subjects such as cars, but they tend to be too hot for food or portrait photography. The example shown is a focusing spot, where the light beam can be spread out or focused down to a small area, ideal for putting light onto small objects.

▲ **BULB TYPES**
From left to right: high-intensity spotlight bulb, giving off a large amount of light from a small bulb; reflector bulb, where the light is diffused by the reflective surface at the end of the bulb; two sizes of photoflood bulb for use in flood lamps.

HAND-HELD LIGHT METERS

It is often useful to have a hand-held light meter, which can measure continuous lighting such as daylight or tungsten, or the brief light produced by electronic flash. Some meters can measure both, and calculate the relative amounts of daylight and flash to expose a scene correctly. In the example shown, a flash meter, the display shows that an aperture of *f*45 is required with 100 ISO film.

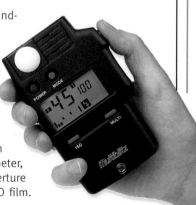

filtrations for certain types of tube. For example, when using a cool white tube with Fuji Velvia transparency film, you should use the recommended combination of 40 Magenta and 5 Red color-compensating filters to counteract the predominantly green cast (see below).

COLOR TEMPERATURE Different light sources are given a color temperature, denoting their predominant color. Color temperature is based on the Kelvin scale, which is used mainly by physicists to evaluate light sources. In simple terms, if you subject a piece of metal to a progressive rise in heat, it first glows a dull orange color, then turns red, and gradually, if the temperature is high enough, becomes white. The system is a measure of the relative amounts of red or blue light in a light source. The more blue, the higher the color temperature.

As previously mentioned, daylight is a highly variable light source, particularly in its color temperature. At sunrise and sunset, the sky can become very orange, even red, while at noon on a bright summer's day the sky will be a vivid blue. Increasing amounts of cloud cover add to the blue color, and color temperatures can rise to well over 10,000K (that is, 10,000 degrees Kelvin). This explains why pictures taken in dull, overcast conditions have a cold, blue appearance. You can correct this to some extent by using a warming filter (see Filters).

The importance of the color of a light source cannot be overemphasized. Color films are designed, or balanced, to give their correct color in certain color temperature light. Therefore, tungsten-balanced film will only give the correct color in lighting of 3200K, for example.

COLOR TEMPERATURE

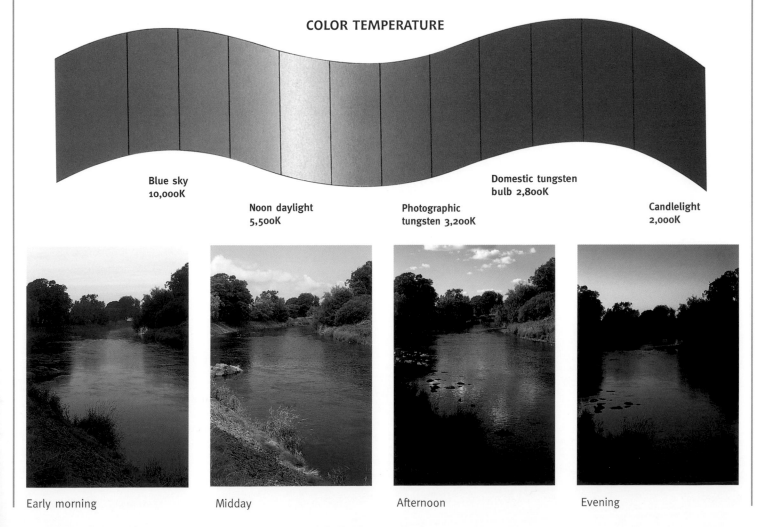

Blue sky
10,000K

Noon daylight
5,500K

Photographic
tungsten 3,200K

Domestic tungsten
bulb 2,800K

Candlelight
2,000K

Early morning

Midday

Afternoon

Evening

BASIC COLOR THEORY It will be worth your while to have a rudimentary knowledge of how different colors are formed. This will be useful both when color printing, and when determining which filter to use for photography.

The human eye has only three types of color-sensitive receptors, which are called cones. These are sensitive to red, green, and blue light. All other colors, such as yellow or brown, are made up of relative amounts of each of these three colors. Red, green, and blue are known as primary colors. The three primaries added together make white, and are known as "additives." If three patches of light – red, green, and blue – are projected so that they overlap, the resulting color is white. White, therefore, is an equal mixture of red, green, and blue light.

Combining two additive primaries gives a secondary, or subtractive, color. For example, a mixture of red and green will give yellow; red and blue will give magenta; and blue and green will give cyan. Another way of looking at this is that white light minus the blue component is yellow, and so on. Blue and yellow are known as opposite, or complementary, colors. Therefore, if a transparency has a blue cast, you need to use a yellow filter to correct it. Red and cyan, and green and magenta, are also complementary pairs of colors. (Reflective colors, as used in painting or printing, combine in a different way. Primary reflective colors are red, yellow, and blue, which combine to produce black.)

SETTING UP A SMALL HOME STUDIO Almost any room in the house can be put to use as a small studio for portraiture or still life work. Obviously, the larger the subject, the more space you will need. Your equipment will depend entirely on what you are going to photograph, but you can do a good deal of work with

▶ AN "IDEAL" HOME STUDIO

1 Safe, for storing equipment
2 Office area
3 Makeup area for models
4 Backdrop
5 Storage area for backdrops
6 Shelving unit for lighting accessories
7 Rolls of background paper

just one light and various reflector boards. Two lights will increase the potential for a wider range of lighting effects, while a third can be used to add effects to the background, or to backlight the subject. For small still life subjects, you may need nothing more than an ordinary reading lamp, but a small electronic flash unit will be more versatile. Use slave cells to link the flash units so that you keep trailing wires to a minimum.

For portraiture, a paper background roll may be useful, but look around for various textiles, some of which can be obtained at very little cost as remnants from fabric stores. You can paint hessian and canvas repeatedly with canvas paint to provide a range of inexpensive backgrounds. Look at books of photographs to see what backgrounds other photographers have used. Above all, don't be frightened to experiment with different ones.

If you have the space, then a good studio should have separate areas for photography, food preparation, and office work as well as a changing room. Try to keep the actual photography area free from clutter, with lights mounted on the ceiling if possible.

PRIMARY AND COMPLEMENTARY COLORS

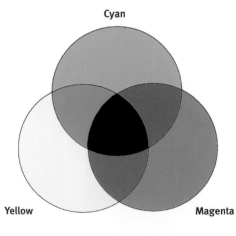

Additive color mixing

Blue

Green Red

Subtractive color mixing

Cyan

Yellow Magenta

◀ In additive color mixing, the primary colors red, green, and blue combine to make white. Where only two colors intersect, complementary colors are formed. Thus, white light minus the blue component is yellow; blue and yellow are known as complementary colors. In subtractive color mixing, the three complementary colors cyan, magenta, and yellow combine to produce black. Where only two overlap, other colors are formed. Thus, where magenta and yellow overlap, red is formed, the complementary color to cyan.

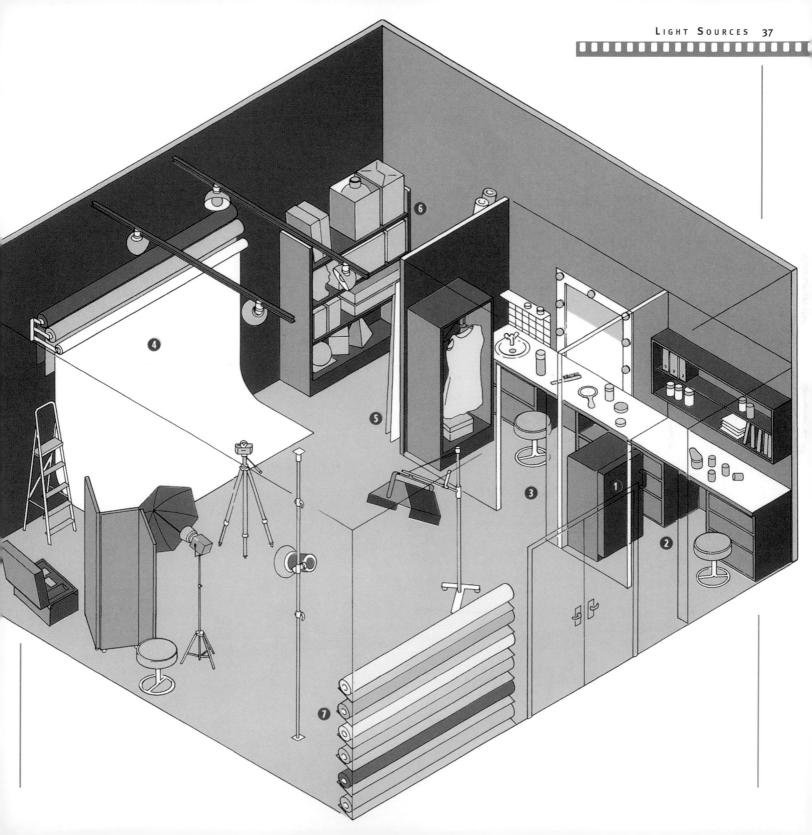

Photographic Accessories

There are many types of photographic accessories and add-ons from which to choose, but you should be sensible about what you purchase. Make sure that the accessories you buy are going to be useful, and don't carry them with you unless you really think you might need them.

CAMERA BAGS Expensive cameras and lenses must be protected from the weather, as well as possible knocks and bumps. You should therefore have a good bag in which to put your equipment. Gadget bags, which are carried over the shoulder, are fine if you carry only small amounts of equipment. However, if you have a reasonable amount, and may be walking for any length of time, it is worth considering a rucksack that has two straps and distributes the weight evenly across your back. You will find this far more comfortable, even if the equipment is less accessible. Other types of bag include those that strap around the waist.

PHOTO VEST Various waistcoats are available, similar to those worn by flyfishers. They have a number of pockets into which you can put film, filters, and other accessories. They are excellent if you need to keep on the move, and need to have the accessories handy at all times. Be careful not to fill them up so that they become uncomfortably heavy, though.

MOTOR DRIVES Most modern SLRs have built-in motor drives, but it is possible to fit motor drives to many older models as well.

Motor drives have a dual purpose. First, they advance the film automatically, and second, they shoot a rapid sequence of pictures. On some cameras they can shoot at up to seven pictures per second, giving excellent potential for action sequences,

☞
Lenses, pages 26–31
Close-up photography, pages 46–51
Filters, pages 58–63

◄ RIGID CAMERA CASES
Bags for transporting camera equipment are available in a wide range of shapes, sizes, and materials. Molded aluminum cases are great for storing equipment, and transporting it in planes and cars, but are not easy to carry.

▲ ► SOFT CAMERA CASES
These tend to be lighter than rigid cases. Many can be carried on the back rather like a rucksack, thus spreading the weight evenly. Ever-ready camera cases generally just hold a single camera body with lens, and have no extra room for other lenses or film.

▼ LENS CASES
Soft pouches (left) are excellent for carrying in pockets or rucksacks, but will not give such good protection as rigid cases (center). Plastic boxes (right) are not suitable for transporting lenses in the field, as they might shatter and damage the lens inside.

but take care: at seven frames per second, you will use a 36-exposure film in just over five seconds, which could be very expensive if you make a mistake.

FILTERS There are a large variety of filters for the photographer. Some are made specifically for color or black-and-white film; others can be used in all types of photography. There are also many filters to produce specific special effects. (See Filters.)

ACCESSORIES FOR CLOSE-UPS Various accessories, such as supplementary lenses that screw onto the front of camera lenses, and extension bellows and tubes, are available for taking close-up pictures. (See Close-up Photography.)

OTHER USEFUL ACCESSORIES When photographing landscapes, particularly with a wide-angle lens, it is easy to get the horizon slightly crooked. You can place a small spirit level on top of the camera to prevent this from happening, and achieve a perfectly horizontal horizon. Camera tripods often have small bubble spirit levels built in to assist with camera leveling.

A Swiss army knife and jeweler's screwdrivers can also be useful. Screws often work themselves loose, and it is well worth carrying a small set of screwdrivers (both flat and Philips head) for on-location maintenance. Swiss army knives are useful for their range of accessories, which may include tweezers and, of course, knife blades.

SPARE BATTERIES Nearly all cameras use batteries, either for the metering system or for their entire operation. If your batteries fail, you may be unable to take pictures. Do not rely on local stores stocking the range of batteries that cameras now require. Take at least one spare, and if you are going away for any length of time, take two or more. Do not handle batteries with bare fingers. Moisture from your fingers can damage them and render them useless. Use re-chargeable batteries for flashguns.

NOTEBOOK AND PEN Use a notebook to record photographic details relating to exposure, film, and so on, as well as details of locations you wish to return to, or other subject details such as the names of plants or people.

▲ COLORED FILTERS
Filters can be used to create a variety of different effects. In this case, the color of a sunset has been accentuated by the use of an orange filter placed in a filter holder over the camera lens.

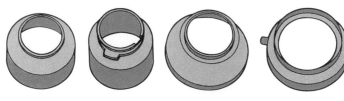

▶ MOTOR DRIVES
Most modern cameras now have integral motor drives, but for those that do not, drives are available as separate accessories. They enable the firing of rapid sequences of pictures, sometimes up to seven pictures per second.

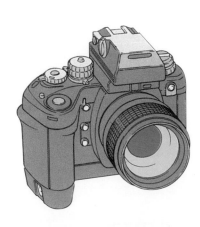

▲ ▶ LENS HOODS AND FILTER HOLDERS
Try to get the lens hood (above) designed specifically for your lens, as it will be most effective for reducing flare. Glass filters usually screw directly into the front of the lens, but acetate filters are best held in special filter holders (right).

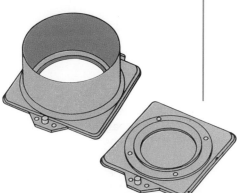

ESSENTIAL SKILLS

HAVING THE RIGHT CAMERA, LENS, AND FILM DOES NOT GUARANTEE A GOOD PHOTOGRAPH; YOU NEED TO HAVE COMPLETE CONTROL OVER ALL CAMERA OPERATIONS IN ORDER TO ENSURE, FOR EXAMPLE, THAT YOU CAPTURE THE RIGHT AMOUNT OF MOVEMENT OR SUBJECT DEPTH. YOU MUST ALSO BE ABLE TO USE FILTERS OR EXTRA LIGHTING TO HELP RECORD THE UNIQUE CHARACTER OF A SUBJECT. THE ABILITY TO MAKE INTERESTING IMAGES FROM DULL OBJECTS IS ALSO VITAL, AS IS AN APPRECIATION OF HOW LIGHT AFFECTS YOUR SUBJECT. THESE ARE THE ESSENTIAL SKILLS OF PHOTOGRAPHY.

Atmosphere

Capturing the particular qualities and atmosphere of a subject, whether it is a tranquil rural scene or a stormy sea, is one of the great skills in photography. It is all too easy to appreciate the potential of a wonderfully atmospheric scene, photograph it, and then be disappointed with the results.

The skill required to achieve atmospheric photographs is that of knowing how to capture the essence of the moment. For most of us, this only comes through practice. You also need to know when to isolate part of the scene and when to capture the whole panorama in order to create the mood you desire. Atmosphere and mood are often inherent in the physical features of the scene itself – for example, when there is mist or fog rather than bright light. Many people only think of taking photographs on bright, sunny days, but these do not necessarily produce the most atmospheric results. However, even in bright, more mundane weather conditions, atmosphere can often be enhanced – for example, by using soft focus, graduated filters, or coarse-grained film to simulate a misty atmosphere.

☞
Film, pages 22–25
Filters, pages 58–63
Focus, pages 66–69
Weather conditions, pages 88–89

▶ MORNING MIST
This photograph was taken at first light, when a slight mist accentuated the sun's rays. It is worthwhile bracketing for photographs of this type in order to ensure you get the best exposure for the conditions. Remember, this will not necessarily be what the meter tells you.

▲ DAPPLED LIGHT
The photographer has managed to capture the very essence of this bluebell wood. In scenes such as this, dappled light can produce lots of contrast, so choose a bright but slightly overcast day to shoot such a picture in order to avoid harsh shadows.

▲ CLOUD FORMATIONS
The romantic atmosphere of Paris in late evening is enhanced by a wonderful cloud formation. The dramatic light in the sky is reflected in the water, leaving the boats, monuments, and other architectural features almost in silhouette.

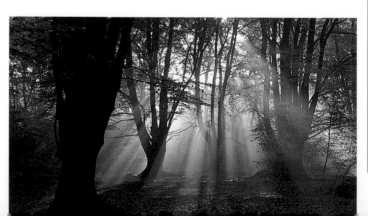

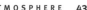

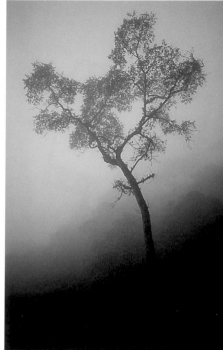

▲ ISOLATED SUBJECTS
This tree on a hillside is isolated by the mist, adding an atmospheric quality to the photograph. Had there been more detail in the background, it would probably have distracted from the main subject of the picture.

◀ EVENING LIGHT
This photograph of low tide on a sandy beach could have been rather uninteresting, were it not for the late evening light glinting off the surface. A sense of scale is provided by the figures walking along in the distance.

Character

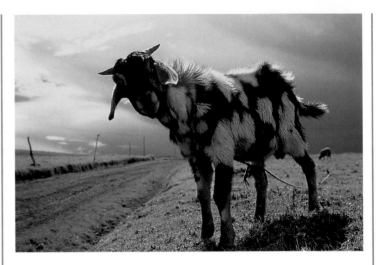

The essential character of a subject, be it a person, animal, or rock, is often an indefinable quality, but one that photographers go to great lengths to capture on film. Lighting, as always, is crucial when trying to portray character, particularly since you are trying to record a three-dimensional texture onto a two-dimensional piece of film.

Texture is an essential element in the character of a subject. Smooth plastic and metal are probably best lit with soft, diffuse light, while heavily textured surfaces, such as tree bark, rock, or even an old man's face, are best photographed with harsh lighting angled steeply to enhance the texture. Translucent subjects, such as leaves or stained glass windows, are best photographed with the light shining through them, but beware of flare when doing this, and make sure you use a lens hood to avoid the problem. It is important to think also about viewpoint and size of the subject within the frame – for example, photographing a subject at an unusual angle can create a particular emphasis that helps to capture the subject's character.

☞

**Light sources,
pages 32–37
Light, shade, and
shadow, pages 72–77**

▲ ANIMAL CHARACTERS
Photographing animals in a way that captures their essential characteristics can be difficult to achieve. Here, the photographer has lowered the position of the camera in order to emphasize the inquisitive nature of the goat, staring down into the camera.

▶ ROUGH AND
SMOOTH SURFACES
Tree bark is found in a wide variety of patterns, colors, and textures, and makes a good subject at all times of the year. In this particular photograph, there is a mixture of rough and smooth surfaces, with a subtle range of color.

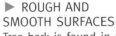

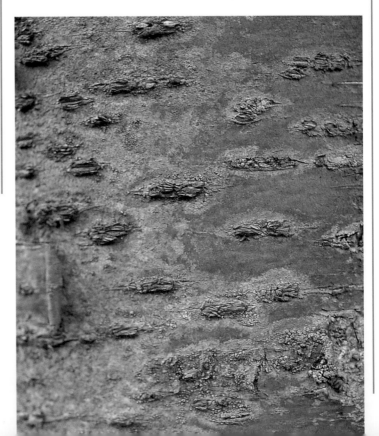

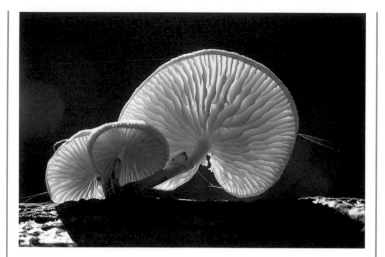

▶ ROCK FORMATIONS
The house appears to be a natural extension of the rock on which it was built. By photographing the subject in rather harsh sunlight, the photographer has accentuated the texture of the rock.

▲ TRANSLUCENT SUBJECTS
The translucent quality of these mushrooms has been captured by photographing them from beneath, with the light placed behind them so that it shines through their translucent caps, particularly at the edges.

◀ WRINKLES AND SKIN
Harsh sunlight brings out the wrinkles and creases in the elephant's hide and its trainer's face, creating an interesting juxtaposition that emphasizes the character of both subjects. Softer light would not have been appropriate here.

Close-up Photography

The world of close-up, or "macro" photography leads to a fascinating world of texture, pattern, color, and shape. While the equipment required is relatively simple, and the basic techniques are easy to master, producing good close-ups is one of the most challenging areas of photography. Attention to detail is essential, and a single misplaced blade of grass, which may well be unnoticed in a normal photograph, can ruin an otherwise perfect close-up.

Close-up photography is all about photographing subjects relatively close to the camera. Most standard lenses will focus to around 3ft (1m) or less (some will focus on subjects 1½ft [50cm] away) and close-up photography starts with subjects closer than this. Another way of thinking about close-up photography is to relate the size of the subject to the size of the image. If a 1in (2.5cm) subject is photographed so that it occupies 1in (2.5cm) on the negative, then the magnification is usually referred to as x 1, having a reproduction ratio of 1:1, or being "life-size." If the same 1in (2.5cm) subject occupies ½in (1.25cm) on the negative, then it is usual practice to say that it has been photographed at x 0.5, or with a reproduction ratio of 1:2. If the same 1in (2.5cm) subject occupies 2in (5cm) on a negative, then it would be twice life-size and referred to as being photographed at x 2, or 2:1.

☞
Cameras, pages 10–15
Lenses, pages 26–31
Flash, pages 64–65

EXPERIMENTING WITH FOCAL LENGTH

28MM LENS Try shooting a subject so that it remains the same size when using lenses of different focal length. Here, the photographer stood 1ft (30cm) away, effectively displaying the subject in its natural habitat.

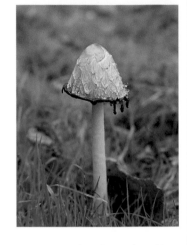

50MM LENS When using this lens, the photographer had to move 3ft (1m) away to achieve the same size image. The background is less obtrusive, but is still sufficiently in focus to provide habitat information.

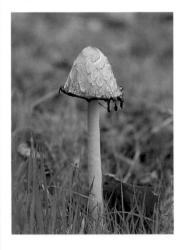

105MM LENS Here, the photographer stood 9ft (3m) from the toadstool. Little of the background is in focus, but the greater working distance would be useful when photographing wildlife, for example.

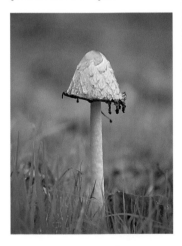

200MM LENS Here, the photographer moved 18ft (6m) from the subject. This lens is ideal for producing beautiful close-ups (particularly of timid wildlife), but the background of the subject will be out of focus.

► LIGHTING
The shiny, smooth plastic wrappers in this arrangement of brightly colored candy are a highly reflective surface. Reflections from the bright studio flash can be seen on the folds of the wrappers, providing the image with vibrant highlights. It was photographed with a simple close-up lens attached to the front of a standard focal length lens.

▼ COMPOSITION
This detail of a peacock feather has an interesting composition, with diagonal lines contrasting with the vertical colored stripes. Feathers frequently make good subjects for close-up photography, and can be photographed using daylight from a window if no other light source is available.

▲ TEXTURE
Objects with an interesting surface texture make excellent subjects for close-up photography. Here, texture has been added to the smooth tomatoes by spraying them with a texture-effect paint.

EQUIPMENT FOR CLOSE-UP PHOTOGRAPHY By far the best type of camera for close-up photography is the single lens reflex (SLR). SLRs do not suffer from parallax, and the viewfinder will show the effect of any attachments placed on the lens. There are basically two methods of obtaining pictures of subjects closer than the lens would normally allow. One is to screw a close-up lens on the front of your standard lens. The other is to extend the distance between the camera lens and the film by inserting either a rigid, fixed-length extension tube, or a flexible bellows unit.

Close-up lenses These are simple supplementary lenses, rather like camera filters, that screw onto the front of a standard lens. They are available in different strengths, known as "diopters." Close-up lenses have an advantage over bellows or tubes in that there is no loss of light involved. Close-up lenses are relatively cheap, but are not always manufactured to the same high quality as the lens to which you are attaching them, and results can be disappointing. Manufacturers such as Nikon and Canon make close-up lenses specifically for their lenses, and while these are more expensive, they give excellent results.

Extension tubes and extension bellows Tubes and bellows both perform exactly the same function: they extend the distance between the lens and the film. The greater the extension, the greater the magnification and closer the working distance. It is easy to calculate the extension required with a given lens by using a simple formula:

EXTENSION = (magnification + 1) x focal length of lens

For example, if you require a magnification of x 1 with a 50mm lens, then: (1+1) x 50 = 100mm. The 50mm lens has 50mm of extension already, so you will need an extension tube or bellows of 50mm to achieve the magnification.

The more you extend the distance from the lens to the film, the further the light has to travel inside the camera. This requires compensation to the exposure if the correct exposure level is to be gained. While the through-the-lens meter will take this into account automatically, you can calculate the compensation with the formula:

COMPENSATION = exposure x $(m+1)^2$

Thus, with a magnification of x 1, four times the amount of exposure is required, or two extra stops. This can be a significant factor in achieving good results, particularly if you are working outside with a low light level.

Extension tubes are often sold in sets of three, allowing a range of magnification choices. Bellows allow greater versatility, but are rather cumbersome and difficult to handle outside. They are also usually far more expensive than tubes.

EXPERIMENTING WITH TUBES AND BELLOWS

STANDARD LENS Most standard lenses only focus down to around 3ft (1m), so they will require some form of close-up accessory to focus in on detail. Compare the following three images with this one in order to see the effects clearly.

EXTENSION TUBE For this image, an extension tube has been used in order to allow the standard lens to focus more closely on the texture of the fabric. The extension tube extends the magnification to x 0.5 (that is, half life-size).

BELLOWS WITH 100MM OF EXTENSION The bellows used to take this image increased the focal length of the standard lens to 150mm, producing an image with a magnification of x 2 (twice life-size).

BELLOWS WITH 300MM OF EXTENSION This produces an image with a magnification of x 5 (five times life-size). This size extension makes the camera difficult to hand-hold, so use a camera support such as a tripod.

EXPERIMENTING WITH MACRO LENSES

MEDIUM DISTANCE
Macro lenses can be used for both "medium" close views and for much higher magnifications. Try photographing the same subject from different distances to see what can be achieved. The picture on the left was taken at around 3ft (1m) with a 55mm macro lens.

CLOSE DISTANCE This shot of the wicker basket was taken from just 10in (25cm) away with the same 55mm macro lens. If you want to photograph living subjects, a 105mm or 200mm macro would be useful, as you would be able to achieve close-ups at a greater working distance from the subject.

CHOICE OF LENS One major problem is that as you increase the magnification, you move the lens closer to the subject. In the example given above, the front of the lens will be approximately 50mm away from the subject. This might be acceptable for still life subjects such as coins, but probably not for insects or other live subjects. Also, the very short working distance does not give much room to illuminate the subject with artificial lights such as flash.

One way around this is to use a longer focal length lens. If you double the focal length, you will need twice the amount of extension, but you will be twice the distance away from the subject. In the example above, a 100mm lens will require 100mm of extension, but will now be 100mm away from the subject. Many photographers who specialize in photographing butterflies and other insects use 100 or even 200mm lenses for their work.

Specialist macro lenses are available that have been specifically designed to produce their best results when used close to the subject. They are more expensive than their conventional counterparts, but are well worth the investment if you intend doing a lot of close-up work. They can also be used as normal lenses, for non-macro work. Macro lenses are available in a range of sizes, usually 55, 105, and 200mm. Many zoom lenses have a macro facility, which again is well worth looking for when considering a purchase.

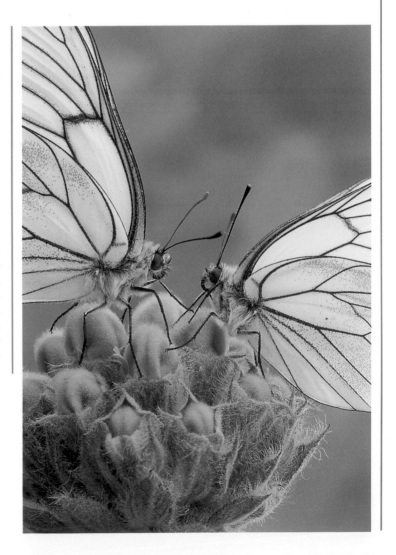

► INSECTS
These superb specimens of green-veined white butterflies are shown to good effect against an out-of-focus background. Depth of field is very limited in close-up photography, and ensuring that these two insects were in the same plane was not easy.

DEPTH OF FIELD Perhaps the most important photographic problem is that of limited depth of field. The closer you move toward the subject, and the higher the magnification, the more limited the depth of field becomes. The table below gives a couple of examples to illustrate the problem:

		APERTURE		
		$f5.6$	$f11$	$f22$
MAGNIFICATION	X 0.5	2.2	4.4	8.8
	X 1	0.8	1.6	3.2
	X 2	0.28	0.56	1.2
	(figures are in millimeters)			

Even at the relatively small aperture of $f22$, at a magnification of x 1 (life-size) you only have just over 3mm of depth of field – certainly not enough for many subjects.

There is no easy answer to the problem. Obviously, make sure that you focus on the most important part of the subject (the eye if it is an insect), and try to arrange for the subject to lie parallel to the film plane if possible. The question to ask yourself is, do you really need to photograph the subject at such a high magnification? Look at books of good close-up photographs; you will see that very often the subject does not necessarily occupy the whole frame.

LIGHTING Lighting principles for close-ups are much the same as for any other photographs, except that everything needs to be arranged in a much smaller space. If the front of your lens is only 100mm away from the subject, there is not much room for large studio flash units. Small portable electronic flash units are very convenient for close-up work, and many can be linked to the metering system within the camera, giving an automatic exposure measurement.

Special "ring-flash" units are available that screw into the filter mount on the front of the lens. These units were originally designed for medical and dental photographers. They have a circular flash tube, and provide a very flat, even light across the whole subject, without any relief or character. This may not be appropriate for subjects that have depth or texture, so try masking off one-third of the tube with black tape to create a more directional light.

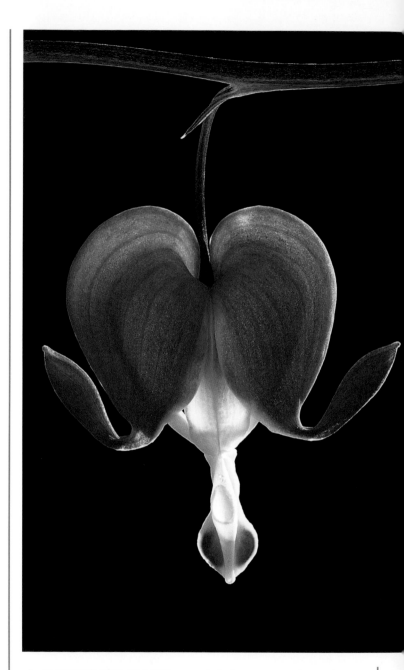

▲ FLOWERS AND PLANTS
This delicate flower has been backlit in order to produce a rim of light around its edges. With photographs such as this where depth of field is narrow, it is important to keep the main plane of the subject parallel to the plane of the film so that maximum sharpness is maintained throughout the photograph.

EXPERIMENTING WITH DEPTH OF FIELD

FROM 5FT (1.5M) AWAY
These images were all taken with a 105mm macro lens. The plant is sharply in focus, but note how the background is rather distracting in this shot.

FROM 3FT (1M) AWAY
By moving closer to the subject, the depth of field becomes narrower and elements of the plant become out of focus.

FROM 1FT (30CM) AWAY
With increased magnification, the front flower clearly becomes the main subject of the shot as the background fades away.

WITH EXTENSION TUBE
Only the central part of the flower is now sharply in focus. The depth of field at such magnification is severely limited.

▶ ABSTRACT PATTERNS
This complex abstract pattern is actually the underside of a bracket fungus growing on the side of a tree. It was taken with a single, heavily diffused flash in order to produce an even light across the subject.

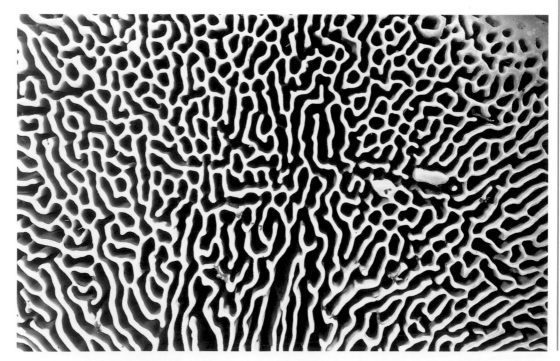

Composition

Hundreds of books and articles have been written about the rules of artistic composition, and the characteristics of a pleasing image. Certainly, there are guidelines to follow, but it is very often those images in which guidelines have been broken, and the rules of composition ignored, that make the most striking photographs.

The position of the elements within the viewing frame is crucial to the composition of the photograph. Newcomers to photography often place their subject exactly in the center, which gives it great emphasis, but frequently leads to dull photographs. Circular shapes such as flowers may work well when placed in the middle of the frame, but consideration must also be given to the background elements.

THE RULE OF THIRDS Many photographers and artists use the "rule of thirds" as an aid to composition. This divides the frame area into nine segments by placing imaginary lines at one-third intervals along the horizontal and vertical axes. Place the main part of your subject on one of the four points that are formed where the lines intersect. Although this might appear to create an imbalanced composition, the subject will be counterbalanced by the remaining two-thirds of the frame.

If you are photographing subjects with strong horizontal lines, such as the horizon on a landscape, try placing this in one of the "thirds" rather than in the middle of the frame. This will lead to a much more dynamic composition. Similarly, place diagonals along thirds rather than through the middle of the frame if possible. Do spend time looking at other people's photographs and paintings, to see what works and what doesn't work, and don't be afraid to experiment.

☞
Framing, pages 70–71

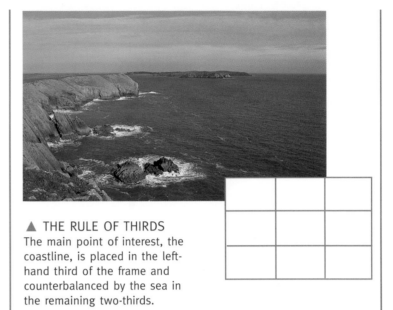

▲ THE RULE OF THIRDS
The main point of interest, the coastline, is placed in the left-hand third of the frame and counterbalanced by the sea in the remaining two-thirds.

EXPERIMENTING WITH VIEWPOINT

This series of photographs of the same tree demonstrates how different images can be created by a simple change in viewpoint, or angling of the camera. The tree, spotlit by the sun, stands out vividly against the dark foliage in the background.

▶ BACKGROUND INTEREST
This butterfly has been placed fairly centrally in the picture frame, but the lines radiating from its underparts make an interesting background of diagonal lines that enlivens the composition.

◀ CAMERA ANGLE
The camera has been angled so that the diagonal lines on this striking Los Angeles building run dramatically across the foreground of the picture, producing a dynamic composition. The blue sky has been darkened by the use of a polarizing filter.

Controlling the Camera

Understanding your camera, and knowing how the controls operate and relate to each other, is essential for obtaining good-quality photographs. As we have seen, cameras are relatively simple devices, with a shutter, lens, and aperture, a means of assessing exposure, and film on which to record the subject.

Correct use of each control, and perhaps more important, learning how to predict the outcome, are necessary if you are to take the pictures that you want. A good photographer has control over every element of the photograph, from shutter speed, aperture, and film type to the background and lighting of the subject.

Having said that, however, photographers often need to compromise. For example, if the level of light is insufficient for your chosen film and depth of field, you may have to use a slower shutter speed than you would like. This could lead to image blur if the subject is moving. You may then have to make a decision – use the slow shutter speed, or open up the aperture and get less depth of field, or use a faster film. While most modern cameras can do this for you automatically, you need to understand what is happening so that you can make informed choices yourself. For example, your camera should have a manual override, so that you can set the exposure yourself. Pure white flowers or black cats can easily deceive built-in exposure meters, so you must have the ability to override any automatic settings. Similarly, many modern cameras have autofocus lenses, which in most instances give excellent results, particularly with moving subjects such as athletes or racing cars, but they can be fooled by others, such as a spider's web, or photographs taken through glass. In such circumstances you will need to focus the lens yourself.

☞

Hardware chapter, pages 8–39

▲ WHITE ON WHITE
You need to have complete control over the exposure if a white subject is to retain detail against a white background. In such circumstances, bracketing your exposures is almost essential.

EXPERIMENTING WITH MOTION BLUR

STATIC IMAGE Successful pictures of the performing arts, in particular those of dancers, rely on creative use of subject blur to enhance the movements of the performers. Here, a fast shutter speed has been used to freeze the movements of the dancers, resulting in a rather static image.

MOVING IMAGE In this picture, a longer shutter speed has produced some blurring of the dancers, giving an indication of the direction of movement and so adding to the atmosphere of the occasion. Try taking photographs of the same subject at different shutter speeds and compare the results.

EXPERIMENTING WITH SHUTTER SPEED

1/1000 SECOND SHUTTER SPEED
The choice of shutter speed is very important when photographing moving objects. The quick shutter speed used here effectively freezes the movement of the cyclist.

1/60 SECOND SHUTTER SPEED
A much slower shutter speed has been used to take this photograph. The cyclist is now blurred, which helps to impart more of a sense of movement, but is still recognizable.

1/8 SECOND SHUTTER SPEED At this very slow shutter speed, the cyclist has become a total blur. You must decide before you take the shot how much blurring you want in your photograph.

Film Speed

Photographic film is available in a variety of sensitivities, or speeds. In general, the slower the film, the better the quality. Slow films are usually sharper; can record, or resolve, fine detail; have better color saturation; and have a finer grain structure.

However, slow film requires a lot of light, and there will be many instances where light levels are a problem, or where a fast shutter speed is required to stop action. In these cases, you will have no other choice but to select a more sensitive, or faster, film. There are now many excellent fast films on the market, with speeds up to 1600 ISO and more.

Fast films have larger silver halide crystals on the film's emulsion that require less light than the smaller silver halide crystals on slow films. The larger crystals produce a grainier, less detailed image than small crystals. However, while faster films do not record as much detail as slower varieties, their more prominent grain structure can be used to creative effect with appropriate subjects. Indeed, many photographers use special processing techniques for enhancing the grain structure of their images.

☞
Exposure, pages 18–21
Film, pages 22–25
Light sources,
pages 32–37

▲ FAST COLOR FILM
This photograph was recorded on fast color transparency film, with the coarse grain enhancing the scene. Tungsten lighting has produced an overall orange cast to the image, resulting in a very warm feeling.

▲ FAST BLACK-AND-WHITE FILM
This photograph of a young dancer is greatly enhanced by the coarse grain of the fast black-and-white film that was used. Fast film results in lower contrast than slow film, which complements this subject.

▶ SLOW BLACK-AND-WHITE FILM
Fine grain black-and-white film is ideal for studio portraits – such as this one of a young girl – as well as technical photographs where it is essential that the photographer records as much detail as possible.

Filters

Filters select certain wavelengths of light and remove them from the light passing through a lens. A blue filter, for example, absorbs red and green wavelengths and transmits only blue wavelengths. A yellow filter, on the other hand, absorbs blue, and transmits red and green. (When mixed together, red and green wavelengths combine to make yellow.)

There are many hundreds of filters available to the photographer, but they can generally be broken down into a relatively small number of categories.

CONTRAST FILTERS Contrast filters are available in six colors: red, green, blue, yellow, magenta, and cyan. They are used to lighten or darken certain tones in black-and-white images. For example, if you are photographing a bowl of fruit on black-and-white film, although your eyes tell you that apples and oranges are different colors, on black-and-white film they may appear the same tone because they reflect the same amount of light. We can therefore use filters to darken or lighten tones selectively.

To lighten a color – use a filter of the same color

To darken a color – use a filter of complementary color

For example, if you want to darken a blue sky, use a yellow filter. If you want to lighten a green apple, use a green filter. Do remember that the filter covers the whole image, so other objects of the color you are altering will also be affected.

☞

**Light sources,
pages 32–37
Photographic
accessories,
pages 38–39**

EXPERIMENTING WITH CONTRAST FILTERS

When viewed in color (near right), the difference between a red tomato and green lettuce leaves is obvious, but not so in black-and-white photography. Try some experiments with filters to create contrast. A red filter has been used in the center right picture, which lightens the color of the tomato and darkens the lettuce leaves. In the far right photograph, a cyan filter has been used, which darkens the tomato and lightens the lettuce.

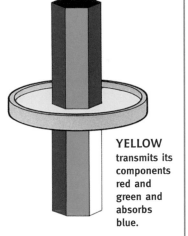

HOW FILTERS WORK

Primary color filters allow only that particular primary color to pass through – that is, red allows red to pass through, blue allows blue, and green allows green. Complementary color filters work in the same way. Yellow is a mixture of red and green, so a yellow filter allows only those two colors to pass through, and so on.

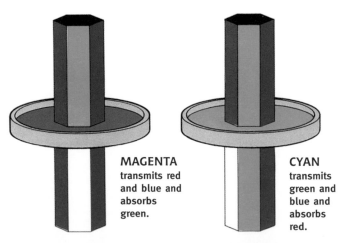

**YELLOW
transmits its
components
red and
green and
absorbs
blue.**

**MAGENTA
transmits red
and blue and
absorbs
green.**

**CYAN
transmits
green and
blue and
absorbs
red.**

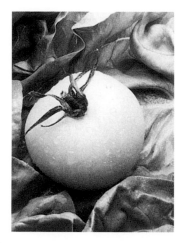

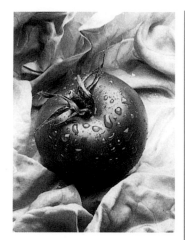

EXPERIMENTING WITH COLOR CONVERSION FILTERS

COLOR CONVERSION FILTERS These filters convert a particular color film to a particular light source – for example, to enable you to use tungsten-balanced film in daylight. The two most common types are:

Kodak 80A for daylight film in tungsten lighting

Kodak 85B for tungsten film in daylight

COLOR COMPENSATING FILTERS Known as CC filters, these allow you to compensate for slight variations in color film batches, or make subtle changes to color balance. For example, they allow you to compensate for slight variations in color from different flashguns. If test shots are slightly green, you can use a weak magenta CC filter to correct it. Film manufacturers make specific recommendations for various situations.

Color film is balanced to give the correct colors at a certain color temperature. When the film is used in the wrong color light, a cast appears. Color conversion filters are used to convert films balanced for a particular type of light to a different light source. Here, a conversion filter has been used to convert daylight balanced film (inset) to fluorescent lighting (above). There are many different types of fluorescent lighting, so try experimenting with different filters to get the right color.

◀ COLOR COMPENSATING FILTERS
Bluebells and other blue flowers are notorious for being difficult to photograph in terms of their color. They reflect a large amount of infrared and ultraviolet radiation, which causes them to record as pink rather than blue flowers. In this case, a pale blue color compensating filter has been used to restore the blue color. If too strong a filter is used, however, the leaves and other parts of the scene will also be given a blue cast.

LIGHT-BALANCING FILTERS These filters are used to "warm up" or "cool down" the colors in an image. For example, taking color pictures on dull, overcast days, when the light has a very high color temperature, will result in "cold" pictures with a bluish cast. A warming filter such as a Kodak 81A can be used to counteract this. Use a cool-down filter near the start and end of a day when you wish perhaps to neutralize a slightly orange or pink sky. Light-balancing filters are available in different strengths.

SKYLIGHT FILTERS The skylight (ultraviolet absorbing) is a general-purpose filter that has two important uses. First, it absorbs ultraviolet light, which the human eye cannot see but to which film is sensitive. The effect of ultraviolet is most apparent in scenes such as bright sun on snow, when the white snow records with a bluish cast as a result of the high amount of reflected ultraviolet light. Second, and perhaps more important, the filter protects your lenses. It is an extremely weak filter, with no effect at all on exposure levels. It acts more like a sheet of plain glass in front of your lens, protecting it from rain, sand, grit, and so on. It is far cheaper to replace a skylight filter than to repair a damaged lens.

EXPERIMENTING WITH SKYLIGHT FILTERS

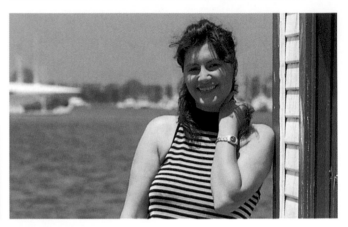

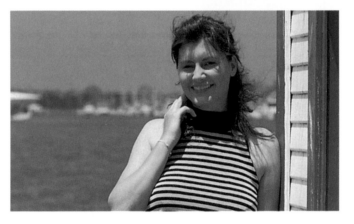

Skylight filters are almost colorless. They are used to absorb any excessive ultraviolet light in order to prevent the appearance of a blue cast. Use them too at all times to prevent damage to the front lens element. Try taking the same shot with (above) and without (left) the filter to see the kind of subtle difference they make to the finished shot.

EXPERIMENTING WITH LIGHT-BALANCING FILTERS

Light-balancing filters are used to warm up or cool down the colors in a photograph. Experiment by taking shots of the same subject using light-balancing filters. In this case, notice the rather cold, bluish tone of the wall behind the model (near right). In the second photograph (far right), a warm-up filter has been used to eliminate the blue cast and give a more natural appearance.

POLARIZING FILTERS Polarizing filters are also general-purpose, and have several uses. They can remove or reduce reflections from shiny, non-metallic surfaces, and they can increase color saturation in subjects such as landscapes. Many landscape photographers use them routinely to darken a blue sky without affecting any of the other colors in the scene. They are made in rotating mounts, so that when attached to the front of the lens on an SLR camera, their effect can be readily seen. Polarizing lenses will require around 1–2 stops more exposure, but camera TTL (through the lens) meters will take this into account.

Cameras with autofocus systems may require a circular polarizing filter rather than the normal linear polarizing filter. Your camera's instruction manual should have this information.

GRADUATED FILTERS These filters are square, and have a gradation of color or tone, with the transition point roughly in the center. They are most used by location photographers for darkening or coloring the top part of a scene. They fit into holders, which allow the filter to be raised or lowered – so that the transition area can be lined up with a horizon, for example. Watch out for objects such as church steeples, which stick up above the horizon. The filter will also make objects darker or alter the color.

EXPERIMENTING WITH POLARIZING FILTERS

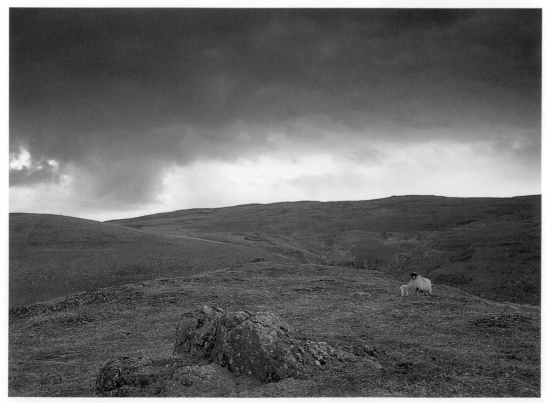

Polarizing filters are used to minimize reflections from non-metallic surfaces, as well as increase color saturation. The photograph above was taken without a filter. In the same shot taken with a polarizing filter (above left), notice that the color of the sea is much denser because the reflections have been removed, and that the greens in the foliage have better saturation. Try some experiments of your own.

◄ GRADUATED FILTERS
This moorland was taken using a neutral density graduated filter in order to darken the sky without affecting the foreground. Notice that the sky has become slightly pink, which sometimes results from the use of these filters with certain types of film.

EXPERIMENTING WITH COLORED POLARIZING FILTERS

In this pair of photographs, the photographer has used a colored polarizing filter with which colors from blue to yellow can be obtained by rotating the filter in its mount. A slow shutter speed has also been used, which blurs the movement of the water and reduces its appearance to that of silk. When conducting your own experiments, take a number of shots of the same subject, working your way around the filter. For moving subjects, try a range of different shutter speeds as well. Although flowing water is one of the most dramatic subjects to photograph in this way, try shooting other moving objects, too.

SPECIAL-EFFECTS FILTERS A huge range of special-effects filters is available from various manufacturers. These include filters for coloring and diffusing subjects – the latter come in a number of forms that can simulate misty or foggy conditions, or simply soften fine detail. More dramatic filters are available that mimic rainbow and starburst effects, as well as filters that create multiple images and distort images. Special-effects filters can make even the most mundane subject sparkle with life, but don't be tempted to overuse them.

EXPERIMENTING WITH COLORED LIGHT

Filters can be placed over the lights used to take a photograph, as well as over the camera lens, particularly if two or more lights are used. In this example, brass door handles (far left) were photographed using several flashes, then shot again (near left) with blue, yellow, and red filters placed over the flashes. Try your own experiments using subjects in a range of textures and colors.

▶ STARBURST FILTERS
This photograph of a ruined building was taken in the evening. It has been enhanced by the use of a starburst filter, which adds a star-like reflection that highlights the photograph. Various degrees of starburst are available, with differing numbers of rays to the star. A small number of rays, such as in this example, generally appears more natural.

Flash

Electronic flash has become the almost universal artificial light source for photographers. It is extremely versatile, the same color as "average" daylight, and relatively cheap. Units come in a variety of sizes, from the size of a matchbox to large studio units the size of a car.

Flash can be used both outside and inside, and can be modified with a huge range of diffusers, reflectors, and other materials (see Light Sources and Light, Shade, and Shadow). By examining natural light and its qualities, you will get a good idea of how to use flash lighting.

STUDIO FLASH UNITS For much studio work, such as portraiture, you may only need one flash unit. Most studio flash units have built-in modeling lights – continuous tungsten lights that allow you to preview the lighting effect. These have no effect on the final picture, because the flash will swamp the tungsten light.

Sunlight can be harsh, producing very dark shadows, or diffused by cloud cover. Both of these conditions can be mimicked to a large extent with studio flash units. A good starting point is to position a single flash unit above and to one side of the subject. Varying the height and the angle of the flash unit to the subject will change the shape and character of the shadows in the final image. The quality of the light can then be altered by diffusing or reflecting the light.

☞

**Light sources,
pages 32–37
Light, shade, and
shadow, pages 72–77**

EXPERIMENTING WITH FLASH

Note how an indoor portrait shot using a single, undiffused flash held to the above left of the camera (center) has harsher shadows and lighting than one shot with natural diffuse daylight (top). In the bottom picture, a long shutter speed has been used with flash, allowing daylight to register on the film as well as the flash. In this example, the subject also moved, producing blurring as well as a sharp image.

◀ DIFFUSED
FLASH LIGHTING
This photograph was taken
using a large flashgun fitted
with a diffuser. These are
known as soft boxes, or in the
case of large studio units, fish
fryers. They are used to mimic
the light coming through a
window, and are used most
often by food photographers,
who need to create directional
lighting but retain detail in all
parts of the subject.

Focus

Correct focusing of the lens will result in sharp pictures. There may be occasions, however, when you want to limit the amount of the subject that is in focus, or even to soften the focused image. The amount of the subject that is in sharp focus is known as the depth of field. This is a zone of acceptable focus both in front of and behind the main point of focus (see Lenses).

CONTROLLING DEPTH OF FIELD Controlling depth of field is vital for successful photographs, and the ability to preview it is very important. Many cameras have depth of field preview facilities, and if you are selecting a new camera, this is one feature to consider. Controlling depth of field allows you to isolate your subject against an out of focus background, or to have your whole image sharp. Using a telephoto lens can help to achieve limited depth of field, and many horticultural photographers, for example, use lenses of 100, 200, or even 300mm to isolate a plant from a completely out of focus background.

☞

Cameras, pages 10–15
Camera supports,
pages 16–17
Exposure, pages 18–21
Lenses, pages 26–31
Filters, pages 58–63

▶ INANIMATE OBJECTS Limited depth of field has been used to great effect in this shot of a child's toy, making the image seem to spring with life. With subjects such as this, a number of very different images could be produced by focusing on different parts of the subject.

EXPERIMENTING WITH SELECTIVE FOCUS

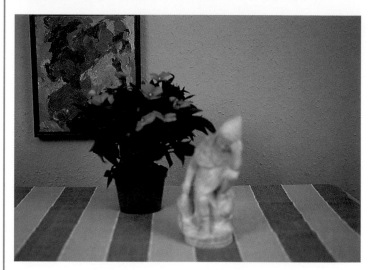

FOCUSING ON THE BACKGROUND It is very important not only to control depth of field, but also to focus on the important part of the subject. Here, the background is in focus, thus rendering the foreground object out of focus.

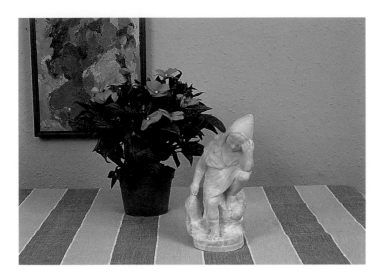

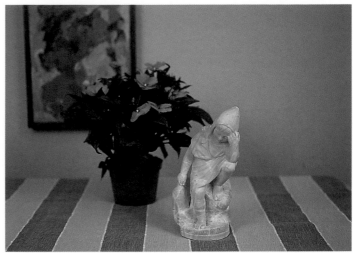

FOCUSING ON THE MIDDLE GROUND In this shot, all of the objects in the image are sharp. This is *achieved by focusing on the flowerpot in the middle, and allowing the depth of field to cover all three objects.*

FOCUSING ON THE FOREGROUND Here, the photographer has focused on the foreground object and allowed *the other objects to go out of focus. Try focusing on different areas of a subject to see the kinds of results you can achieve.*

◄ FOOD PHOTOGRAPHY
Food photographers often choose to focus on particular elements to make the food seem more appetizing – effectively focusing the eyes, and the tastebuds, on the heart of the dish. Here, the focus is on the prawns and the sprig of leaves, with the background and foreground elements of the picture gradually going out of focus. A smaller aperture would have brought more of the image into focus, but this may have distracted from the subject.

EXPERIMENTING WITH SOFT-FOCUS PORTRAITS

"Soft-focus" techniques are commonly used for portraits, particularly of female sitters, and can be achieved in a number of ways: smear a plain sheet of glass with petroleum jelly (near right), using different amounts and patterns of smearing to produce different effects; de-focus the lens slightly to give an out-of-focus picture (center right); or stretch a piece of black stocking over the camera lens to produce a soft-focus image (far right).

EXPERIMENTING WITH SOFT-FOCUS ABSTRACT EFFECTS

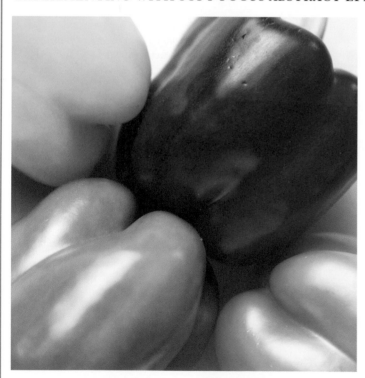

SHARP FOCUS There are many more innovative ways to use soft focus than simply for portraiture. For example, look for a subject in which the color and texture are dominant. Take a sharply focused shot of your subject for comparison purposes.

SOFT FOCUS Deliberately de-focus the lens, so that the point of focus is either in front of or behind the film plane. Note how this produces a lovely abstract effect. Use this method sparingly, however, as it can look like poor technique.

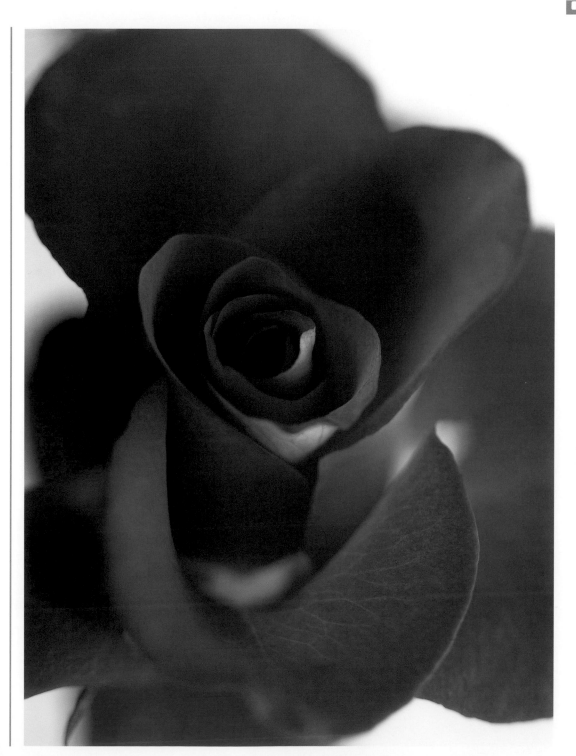

◀ NATURE PHOTOGRAPHY
When photographing natural subjects in close-up, the frame can sometimes become filled with minute detail, detracting from the overall image. Here, a limited depth of field leads the eye to the important elements of the rose – the central petals and the delicate veining on the lower petal, which have been emphasized by backlighting.

Framing

One way to add interest and depth to a photograph is to provide a natural frame for the subject, leading the eye into the picture. Gardens can be photographed through a window, for example, while buildings in crowded cities can be photographed through archways, or between other buildings.

Look through the viewfinder in your camera and try out different angles, viewpoints, and formats. Very often, you may only need to move your camera a small amount to add an effective frame to your picture. For example, the branches of an overhanging tree can be used to provide a natural frame for many landscape photographs. However, the frame that you choose does not have to mirror the subject, but can be contrasting. Good contrast can be achieved by photographing old buildings framed by new ones, and vice versa.

Take care when framing your photographs that the frame itself does not overpower and detract from the impact of your main subject. You can choose whether the frame is in sharp focus or not by using a large or small aperture. The frame should serve to lead the viewer's eye to the main point of interest, not away from it. Take note also of the contrast of light and dark. A dark frame can provide a powerful setting for a lighter subject, such as a light-filled scene photographed through a window frame.

☞

**Exposure,
pages 18–21
Composition,
pages 52–53**

▲ ARCHITECTURAL FRAMES
The curve of the modern office block is mirrored by the curved arch, which forms an effective frame to the photograph. Without the frame, it would have been a very mundane image.

► "NATURAL" FRAMES
This ancient clapper bridge is built over a stream that leads into a natural limestone amphitheater. A single, dark tree branch has been used as an effective frame to the composition, leading the eye to the main subject.

▲ ► "WINDOW" FRAMES
These two Yemeni mosques have been framed through ornate windows. Exposure in such situations can be tricky – make sure you expose for the building and not the frame. You might also need to use a spot metering technique (see Exposure). This type of image works best when the frame is very dark or even black.

Light, Shade, & Shadow

The literal meaning of photography is "painting with light," and it is the quality of light that, in general, contributes to the success of a photograph. It is very often the quality of lighting that characterizes the work of certain photographers, and it is well worth experimenting to try to develop your own style.

Daylight has an infinite variety of qualities, and while many are highly attractive, there are occasions when the quality of daylight needs to be modified to produce an acceptable result. Bright, sunny days can be difficult to work with; it may not be possible for the film to record all of the detail present within the shadow or highlight areas. The human eye is a remarkable device, and can see detail in all parts of a scene, shadow to highlight, with a contrast range of around 1,000 or more to one, or around 10 stops. Photographic film, particularly slow color film, may only be able to record around a five-stop brightness range, and so will lose detail in the shadow or highlight areas, or both.

FILLING IN SHADOW Simple reflectors, or small flash units, can be used to fill in the shadows created by harsh sunlight and thus reduce contrast. For example, if a subject lit by sunlight has a brightness range of 200:1 (that is, the highlights reflect 200 units of light, while the shadows reflect one unit of light), then the film will lose either shadow or highlight detail, or both. If a reflector is used to bounce light back into all parts of the subject, and adds just one unit of light to all parts of the scene, then the shadows now reflect two units of light, and the highlights 201, a contrast range now of 100.5:1.

☞
**Light sources,
pages 32–37
Flash, pages 64–65**

EXPERIMENTING WITH SIMPLE REFLECTORS

*WITHOUT REFLECTOR
Very harsh sunlight has resulted
in dense shadows in this close-up
shot of limpets on a beach.*

*Much of the textural detail of
the rock surface onto which
the limpets cling has been lost
in the shadows.*

*WITH REFLECTOR By
placing a small piece of shiny
white card on the opposite side
to the sun, some light has been
reflected from the sun back into
the shadows, producing a much*

*more evenly balanced image.
Reflectors can be of any size,
from small pieces of card to
large white sheets. Try covering
a piece of card with tin foil for
different results.*

◀ DEEPLY CONTRASTING
LIGHT AND SHADE
Woodland scenes can be
difficult to photograph if the
dappled light has deep
contrasts. Here, a scene in
late summer has been
captured perfectly, with the
detail in both highlights and
shadows preserved through a
well-exposed transparency.

REFLECTORS Reflectors can be made from white paper, white polystyrene, and even the silver lids from takeaway cartons. Special folding, circular reflectors with a number of reflective surfaces are available from photographic stores in a range of sizes and finishes, including white, silver, and gold. Gold ones are often used on dull, overcast days to warm up the tones of a subject in much the same way as a warm-up filter. They are extremely useful accessories, and many photographers carry at least one with them at all times.

When photographing people outside in sunny conditions, a shadow will be formed under the chin. A professional photographer will often ask a model to hold a reflector under the chin to bounce light into the shadow.

FILL-IN FLASH Small electronic flash units can be used like reflectors to fill in the shadows created by harsh sunlight. They are often used by wedding photographers, for example, to fill in the shadows under the brims of hats on sunny days. The basic idea is to fire a flashgun during a daylight exposure. Aim to expose correctly for the daylight, and to underexpose the flash by between one and two stops (the simplest way of doing this is to set the film speed indicator on the flash by two stops more than the film you actually have in the camera – that is, if you have 100 ISO film, set the flash to 400 ISO). You will need to carry out some experiments, and probably bracket your exposures.

EXPERIMENTING WITH GOLD REFLECTORS

WITHOUT REFLECTOR Shoot an outdoor portrait in direct sunlight, like the one shown here. Observe the deep shadows that fall over the face.

WITH REFLECTOR Improve the shot by holding a large gold reflector to the side of the sitter to bounce warm light back into the shadow areas of the face.

▶ SHAFTS OF LIGHT
This simple photograph of some bottles and a chair would have been rather uninteresting without the shafts of light, which come through bars at the window.

EXPERIMENTING WITH FILL-IN FLASH

WITHOUT FILL-IN This shot was taken in direct, overhead sunlight. Notice the harsh shadows caused by the baseball cap.

▲ STUDIO PORTRAITS
A simple studio portrait shot with electronic flash. Two flash guns diffused by umbrellas have been used (note the two catchlights in the eyes). The one from top left was more powerful, and was used as the main lighting; the other provided fill-in to the first.

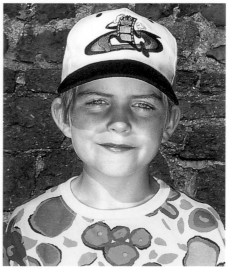

WITH FILL-IN This shot was taken using flash to "fill in" the shadows. Experiment by placing the flash is different positions.

EXPERIMENTING WITH LIGHTING THE FACE

This series of pictures of a model head demonstrates the wide range of effects that can be achieved by changing the direction and diffusion of the lighting. Some of the effects are more usually applied to certain types of subject – soft, diffuse lighting for female portraiture; harsher lighting for male portraiture – but do not be frightened to experiment. Also, try not to make your lighting set-up too complicated. Many of the world's best portrait photographers use just one light and modify its direction or character to suit their purposes. Diffuse light gives a flat appearance, without any modeling, while harsh lighting accentuates the texture and shape of the face.

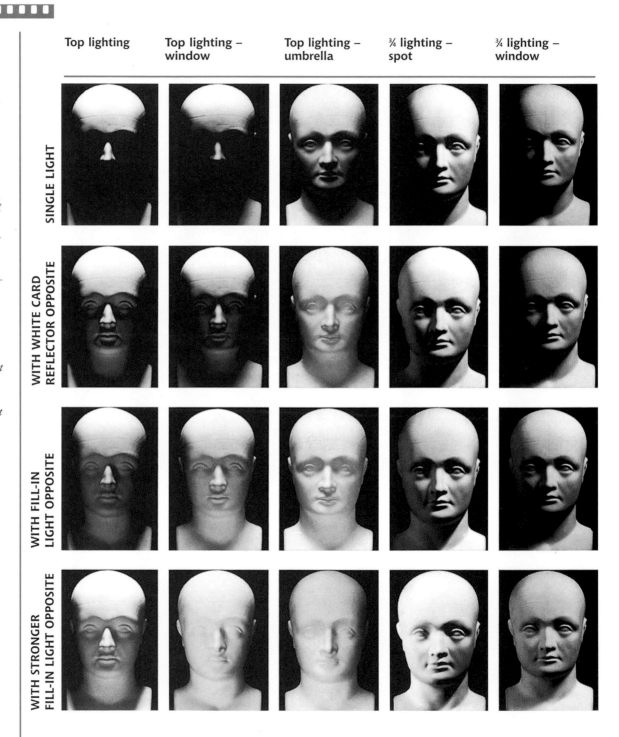

	Top lighting	Top lighting – window	Top lighting – umbrella	¾ lighting – spot	¾ lighting – window
SINGLE LIGHT					
WITH WHITE CARD REFLECTOR OPPOSITE					
WITH FILL-IN LIGHT OPPOSITE					
WITH STRONGER FILL-IN LIGHT OPPOSITE					

¾ lighting – umbrella	Side lighting – spot	Side lighting – window	Side lighting – umbrella	Front lighting	Back lighting

 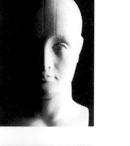

 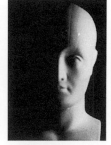 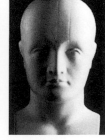

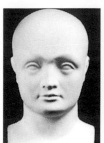 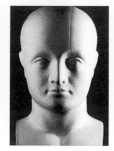

Movement & Shutter Speed

Shutter speed determines the amount of subject movement in a photograph (see Lenses). When photographing a moving subject, such as a car or running horse, you will need a fast shutter speed if you want to freeze the movement. If the subject is still, you can use a slow shutter speed, provided the camera is well supported.

Remember, however, that highly effective photographs of moving subjects can often be obtained by deliberately blurring the image to portray the sense of movement.

FREEZING MOVEMENT There are certain techniques for freezing movement, even with slow shutter speeds. One of these is known as "panning," whereby you follow the subject with the camera and release the shutter as the subject passes in front of you. You will need practice to ensure a smooth pan, and you will need to continue the pan after you have released the shutter. A tripod with a "pan and tilt" head is useful here. The result should be a reasonably sharp shot of the subject, with a blurred background.

Another way to freeze movement is to use electronic flash. The duration of the flash from small portable units is usually in the region from 1/1000 to 1/25,000 second. This makes it an excellent light source for freezing the movement of small subjects such as insects and flowers. Striking pictures can be obtained of normally invisible events, such as a balloon bursting. Larger subjects are more difficult, since they need more light, and you may have to resort to larger studio flash units; these often have a longer duration, in the region of 1/500 second.

☞

Camera supports, pages 16–17
Exposure, pages 18–21
Lenses, pages 26–31
Controlling the camera, pages 54–55
Filters, pages 58–63
Flash, pages 64–65

▲ LIQUIDS
This cocktail glass being filled with liquid has been photographed using a studio flash system. These units tend to have a longer duration than small portable ones, usually in the region of 1/500 to 1/1000 second. This is generally sufficient for photographs such as this, although there is some blurring of the liquid flowing from the glass.

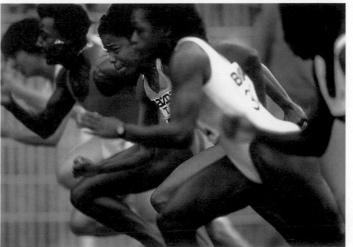

▶ SPORTS SUBJECTS
A fast shutter speed has been used here to freeze the runners at the start of their race. Having no depth of field to work with, the photographer has chosen to concentrate on just one runner to give the image added impact.

▲ A MOMENT IN TIME
The balloon, photographed at the moment of bursting, illustrates an extreme use of flash. The flash has been triggered to fire by the noise of the balloon bursting, which activated the camera by means of a specially built triggering device. The flash itself was set to its minimum power, and thus its shortest duration, around 1/25,000 second. The original shape of the balloon can just be seen as well.

CREATING MOVEMENT In some cases you may want to blur the subject deliberately in order to imply a sense of movement. In this instance, use a relatively slow shutter speed. This can be particularly effective when photographing water, perhaps waves breaking on rocks, or waterfalls. A slow shutter speed reduces the appearance of the water to silk, and can be most dramatic. Experiment with different shutter speeds, from around 1/15 to 1 second or even more.

Another, perhaps more gimmicky technique is to change the focal length during an exposure when using a zoom lens. You will need a rather long exposure time for this technique, perhaps 1/8 or 1/15 second, with the camera again mounted on a tripod. The main subject should be in the center of the frame.

If you find yourself in a situation where you want to use a long shutter speed, but the light is very bright, even stopping the lens down to its minimum aperture would result in overexposure. In this case, use neutral density filters to reduce the amount of light passing through the lens. They are available in different strengths. An ND 0.3 filter reduces the amount of light by one stop, a 0.6 by two stops, and so on.

You can also try deliberately moving the camera during the exposure. Sports photographers often "pan" the camera with their subject in order to achieve a sharp image against a streaked background – a racing car speeding along the track, for example. However, you can also experiment with static subjects.

EXPERIMENTING WITH DELIBERATE BLURRING

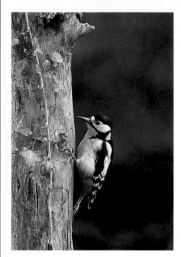

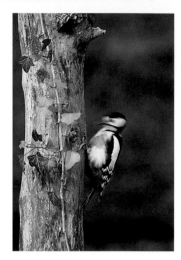

These two photographs illustrate how deliberate use of a slow shutter speed can be used to provide additional information about a subject. The first, normal image (above left) was *photographed at 1/250 second, and the second (above right) at 1/30 while the bird was tapping on the tree. The body of the bird has remained sharp; only the head shows movement.*

◀ STATIC SUBJECTS
This illustrates how a static subject – the neon signs of restaurants at a holiday resort – can produce a striking photograph when it is dealt with imaginatively. By moving the camera during a relatively long exposure, perhaps 1/8 second or so, the photographer has produced a photograph with an impressionist quality. Do not be afraid to experiment with photographs such as this. No two will be the same, and you may need to try several exposures before you get an interesting result.

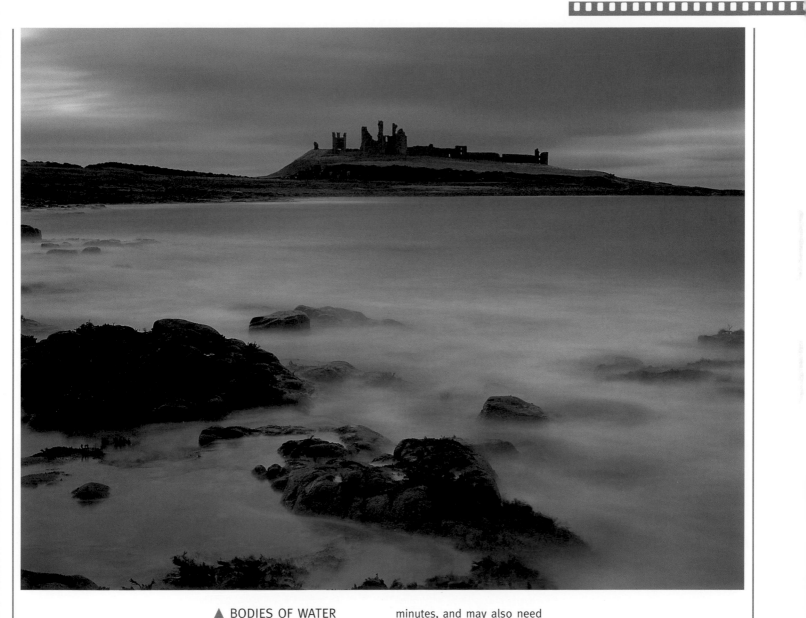

▲ BODIES OF WATER
This rather ethereal photograph of the sea was the result of a long exposure, giving the water a silky appearance. The technique can be very effective with water scenes generally. You may need to use exposures of several seconds or even minutes, and may also need neutral density filters to reduce the amount of light entering the camera. With long exposures such as this, reciprocity failure (see Glossary) can cause the color of the scene to shift, producing blue or other casts, depending on the film used.

Perspective

Perspective is the apparent relationship between objects, according to their position, distance, and so on from each other within an image. The most noticeable effect of perspective in a photograph is that objects in the background appear to be smaller than objects in the foreground.

The effects of perspective are most clearly seen with parallel lines, such as roads and railway lines, which appear to converge as they recede into the distance. The imaginary point at which they would converge is known as the "vanishing point." The same effect is apparent when looking up at a tall building. The sides of the building appear to converge to the vanishing point. This is known as "linear" perspective. Changing your viewpoint – that is, the position of the camera – governs the perspective within a picture.

LINEAR PERSPECTIVE It is often stated that telephoto lenses flatten perspective, and wide-angle lenses exaggerate it. This is certainly true up to a point, but if you alter your camera position (viewpoint) so that the size of the image is the same – that is, you move away from the subject with the telephoto lens, or closer to it with the wide-angle lens – the perspective will be the same with both lenses. Carry out some experiments with different lenses, exploring the various ways in which changing lens and camera position can affect the perspective.

☞
Lenses, pages 26–31
Scale, pages 86–87

▲ LINEAR PERSPECTIVE
This wonderfully evocative photograph of a wine cellar has a real sense of depth. The receding pools of light on the floor, and those from under the barrels, lead the eye into the photograph, giving a good sense of perspective.

EXPERIMENTING WITH DIFFERENT VANISHING POINTS

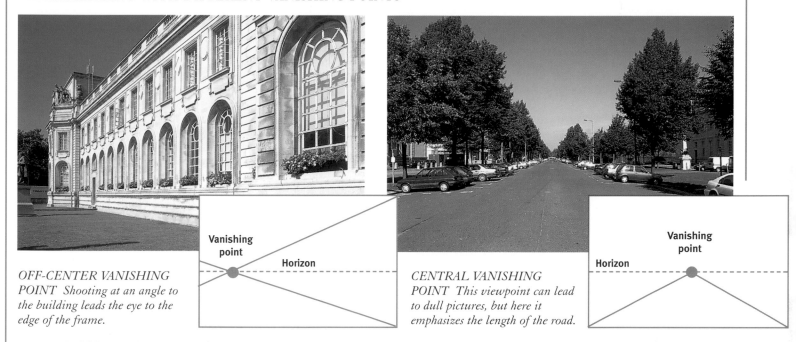

OFF-CENTER VANISHING POINT Shooting at an angle to the building leads the eye to the edge of the frame.

CENTRAL VANISHING POINT This viewpoint can lead to dull pictures, but here it emphasizes the length of the road.

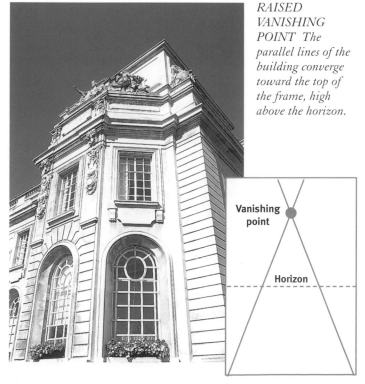

RAISED VANISHING POINT The parallel lines of the building converge toward the top of the frame, high above the horizon.

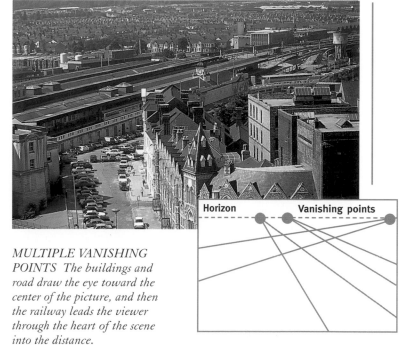

MULTIPLE VANISHING POINTS The buildings and road draw the eye toward the center of the picture, and then the railway leads the viewer through the heart of the scene into the distance.

AERIAL PERSPECTIVE Another type of perspective is known as "aerial perspective," which is more of an atmospheric phenomenon than an optical one (it is sometimes referred to as "atmospheric perspective"). The filtering effects of dust particles in the atmosphere make distant tonal values appear paler than those in the foreground. Many pictures, particularly landscapes, can be given a sense of depth by the way in which tones become lighter the farther they are from the camera, as a result of the effects of haze and mist; at a distance, even the richest dark values in a scene appear dimmed.

Aerial perspective is frequently more apparent in the early morning or early evening, when excellent atmospheric conditions are often found. Even photographs of relatively small areas can be given a considerable sense of depth when taken in misty conditions. The sense of scale can be enhanced by including an object near the camera.

EXPERIMENTING WITH PERSPECTIVE CONTROL LENSES

By shooting from ground level, and needing to include the whole of the building, the photographer has been forced to angle the camera upward, resulting in an image with "converging verticals" (above left). For the shot on the right, a perspective control lens has been used, which enables the photographer to maintain vertical sides on objects such as buildings. Carry out some experiments photographing various types of architecture and shooting at different angles, then take the same shots using a perspective control lens.

◄ AERIAL PERSPECTIVE
This is a good example of aerial perspective, where a sense of depth and distance is produced by changes in color and tone from foreground to background. The tones become increasingly lighter toward the horizon because the mist dilutes the colors and detail.

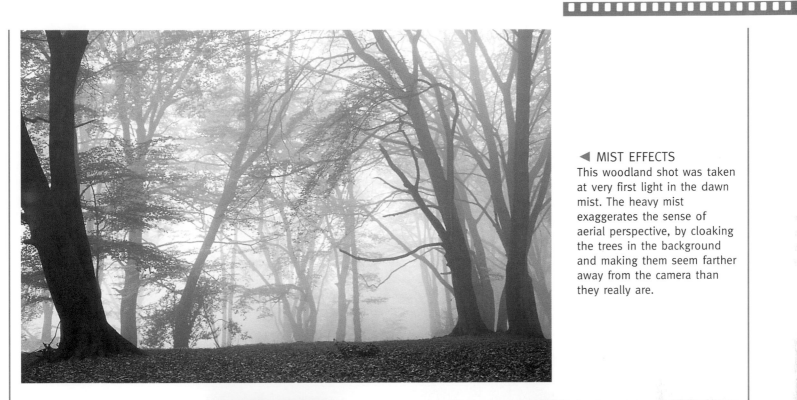

◀ MIST EFFECTS
This woodland shot was taken at very first light in the dawn mist. The heavy mist exaggerates the sense of aerial perspective, by cloaking the trees in the background and making them seem farther away from the camera than they really are.

▶ ARCHITECTURAL PERSPECTIVE
By angling the camera straight up toward the top of the building, the photographer has created a good idea of the building's perspective, with the lines converging at the top. The triangular decoration at the base of the building adds to the effect.

Scale

It is often easy when taking photographs to lose the sense of scale, particularly when doing close-up work, although the same thing can happen with landscapes as well. For example, a close-up of a patch of moss, if there is nothing to compare it with, could be an aerial view of a forest. Similarly, a statue may be just 2in (5cm) high or as much as 15ft (4.5m) tall if there is no other point of reference in the photograph with which to compare it to get an idea of its true size.

Our sense of scale depends on relationships with other objects — we know that a statue is about 6ft (1.8m) tall if a person standing next to it is approximately the same size. However, a lack of any idea of scale may be effective in producing interesting abstract images of well-known objects, especially in close-ups.

A sense of scale is particularly important in fields such as natural history photography, where size could well be used to identify the subject. A simple way of providing a sense of scale is to incorporate an object of known size into the picture. This might be an object such as an oak leaf, pine needle, or fir cone, or people set in a landscape. However, avoid using artificial objects such as coins for scale in natural history photographs.

☞

**Close-up photography,
pages 46–51**

▲ ARCHITECTURAL SCALE
The size of the King Hassan II mosque in Casablanca, Morocco, as well as the intricacy of its decoration, is highlighted by the inclusion of figures at the base.

EXPERIMENTING WITH THE SENSE OF SCALE

▼ NATURAL HISTORY PHOTOGRAPHY
Pine cones have been strategically placed next to the fungi to give a comparison for scale.

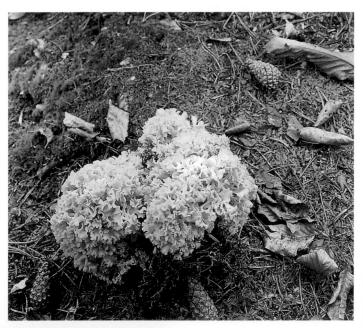

OPTICAL ILLUSION When a 3D object is photographed, it produces a 2D image, so it can be difficult to get an idea of scale. By framing a hand beneath the building, the church appears to be very small and to sit in the palm of the hand.

REALITY When photographed with a person at the church's base, it becomes obvious that the building is in fact fairly large. Creating optical illusions like this can be great fun and produce some interesting results. Don't be afraid to experiment.

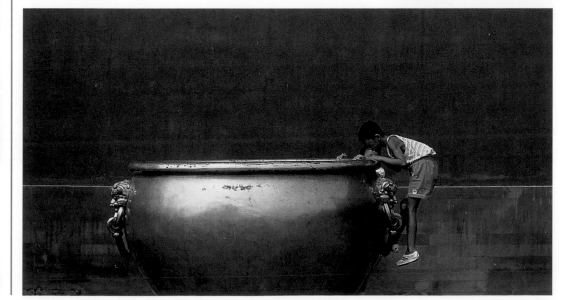

◄ "EVERYDAY" OBJECTS
The small child peering into the copper pot creates an immediate sense of scale. Without the inclusion of figures in the scene, we would have no indication of the immense size of the pot; it would simply seem to be a close-up of an everyday household item.

Weather Conditions

It is remarkable how many people take their cameras with them on bright, sunny days, but leave them behind when it is raining or foggy. While bright conditions may produce "picture postcard" scenes, these are not the most interesting in terms of available light, which is often found when the weather is not "at its best."

Sunny conditions are also not ideal for photographing subjects such as white or pastel-colored flowers, when a bright but overcast sky may well give the best results. It is well worth looking for opportunities that the weather can present. Photographs taken in the rain often have an atmosphere and character all their own, although you must take care of your equipment in such conditions and protect it from the damp. Lightning, of course, can provide some remarkable pictures, but do take great care if you happen to be outside in a lightning storm.

▶ LIGHTNING
Lightning is very difficult to photograph, not least because it is unpredictable. Exposure can be tricky to judge, particularly in daytime. At night, it is relatively easy to point the camera in the direction of the lightning, open the shutter, and let the flash take its own picture. If the shutter is left open for a long period, you may be lucky enough to catch two or even three forks of lightning.

☞
Atmosphere,
pages 42–43

▲ SNOW

Many people put their cameras away during bad weather, but rain and snow can provide atmosphere in a photograph, as demonstrated in this shot of policemen in Red Square, Moscow. Do take care of your camera, particularly modern electronic models, in wet conditions. Try using a plastic bag over the body, with a rubber band around the lens.

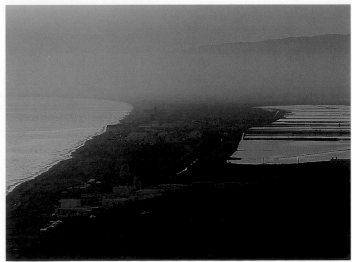

◄ MIST AND HAZE

Look out for mist or haze patterns when you are photographing scenery. In this photograph, a layer of mist seems to hang in mid-air over the coastal town.

PROCESSING & PRESENTATION

ONE OF THE GREAT THRILLS FOR ANY PHOTOGRAPHER IS SEEING THE FIRST PRINT APPEAR IN A DISH OF CHEMICALS. ALTHOUGH MANY DARKROOM PROCESSES ARE NOW AUTOMATED, OR ARE BEING REPLACED BY DIGITAL TECHNOLOGY, DARKROOM WORK IS STILL AN ESSENTIAL PART OF MOST PHOTOGRAPHERS' WORK. THE ABILITY TO CONTROL THE VARIOUS PROCESSES IS A SKILL THAT, WHILE NOT EASY TO MASTER, WILL GREATLY ENHANCE YOUR EXPERIENCE AS A PHOTOGRAPHER.

Darkroom Design

A darkroom suitable for black-and-white and color printing and film processing can be set up almost anywhere there is space in the house, for example in the bathroom or kitchen, or even in a space under the stairs.

All you need when designing a home darkroom is a dark area large enough to load the film into the daylight developing tank. This might be nothing larger than a closet. You do not even need a supply of running water: you can use pails of water to store wet prints and take them somewhere else for washing and drying.

MAIN REQUIREMENTS The room you use should be well-ventilated, as some photographic chemicals give off toxic fumes. You can buy special darkroom vents that allow a flow of air through the room but are lighttight.

You will need an electricity supply for the enlarger and some other pieces of electric equipment. For reasons of safety, you should make sure there is enough space to accommodate a separate wet and dry area.

You will have to have enough space to accommodate an enlarger for printing, developing trays or drum, and at least one person. Cover the floor and work surfaces with a waterproof material such as vinyl. Store items such as focus finders and developing tanks on shelves and make certain that you have a dry storage area for paper. If possible, arrange for any light switches to be pull switches. This should apply to both white light and any safelights. Make sure you stand the enlarger on a flat and stable surface.

If you are able to convert a room as a permanent fixture, you may want to include extra features such as a sink, purpose-built work surfaces, and light traps on the windows. Paint the walls white so that they reflect light, and make sure that the ceiling is high enough so that you can extend the enlarger to its maximum height.

☞
Film processing,
pages 94–97
Printing film,
pages 98–105

▶ AN "IDEAL" HOME DARKROOM

1 Enlarger
2 Film drying cabinet
3 Focusing magnifier
4 Easel
5 Light box
6 Shelf for film-processing equipment
7 Flat-bed print dryer
8 Safelight
9 Extractor
10 Print washing tray
11 Graduate and stirrer
12 Timer
13 Developer, stop bath, and fixer trays
14 Thermometer
15 Contact printing
16 "Dry" storage cupboard
17 "Wet" storage cupboard

▼ USING A BATHROOM AS A DARKROOM

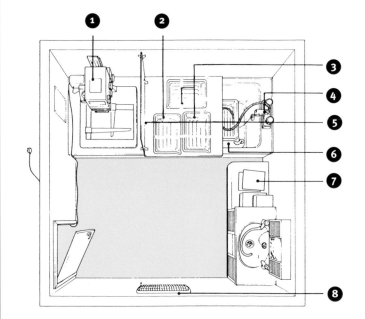

1 Enlarger
2 Developer tray
3 Stop bath and fixer trays
4 Flexible hose
5 Sheet of cardboard to protect enlarger from splashing water
6 Print washing tray
7 Printing paper
8 Red bulb fitted temporarily in light fitting

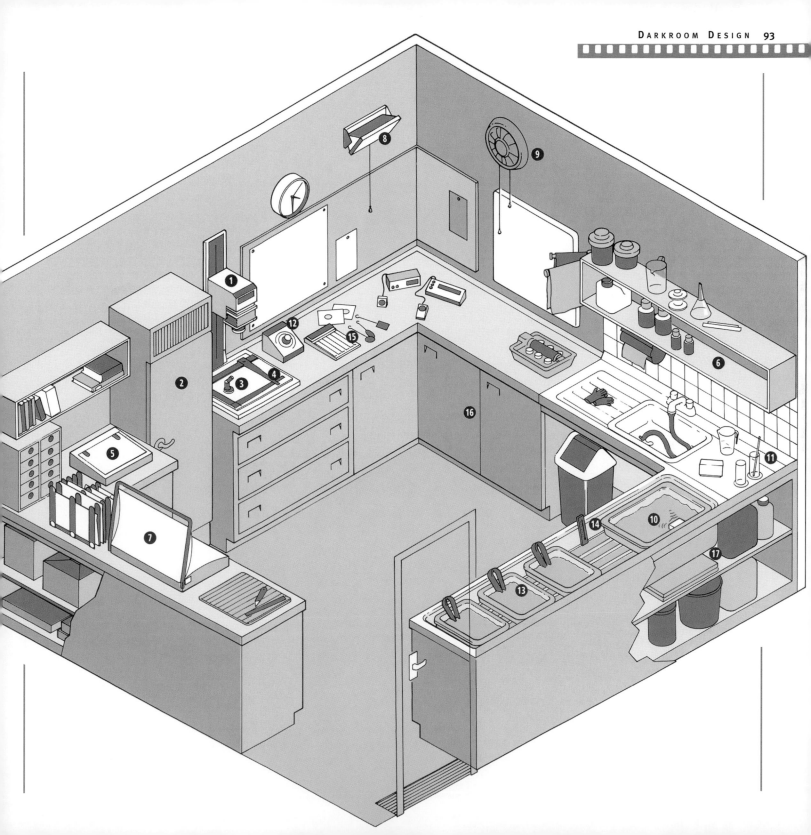

Film Processing

When a film in a camera is exposed to light, the silver halide crystals on the strip of film undergo a chemical change and form what is called a latent image – an image that cannot be seen until the film is developed. Black-and-white film processing is easy to master and requires only a small amount of equipment; color film processing is more complicated.

When black-and-white film is developed, the silver halide crystals are converted into minute grains of metallic silver. The crystals that have not been exposed to light must then be removed, because they are still light-sensitive. They are dissolved during the first stage of processing, the fixation stage. The processing of color film is similar, except that colored dyes, which replace the silver grains, are developed in the film.

BLACK-AND-WHITE FILM PROCESSING This is a relatively simple procedure, which you can carry out almost anywhere where there is a supply of water. Undeveloped film is still light-sensitive, therefore you must first load it into a daylight developing tank in total darkness. If you do not have a lighttight room in which to do this, you can place the film and the tank inside a lightproof changing bag. This is a large cloth bag with a zippered opening and two armholes with elasticized cuffs that prevent light from entering. There are many different types of developer, such as fine grain, speed increasing, or high definition. For your first efforts, use an all-purpose developer. Read the leaflet carefully. This will give the time of development for a particular film, usually in the region of 8–10 minutes. You can increase or decrease the developing time if you need to uprate or downrate the film speed (see Film).

☞
**Film, pages 22–25
Printing film,
pages 98–105**

BLACK-AND-WHITE FILM PROCESSING

1 In complete darkness (use a changing bag if you do not have access to a lighttight room or closet), lever off the end of the film cassette using a bottle opener or special cassette opener. Cut off the leader, or tongue, with scissors, trying to cut between the perforations.

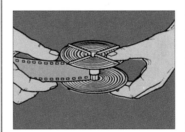

2 Wind the film onto the metal or plastic reel of the developing tank. Some reels have a clip at the center onto which the end of the film should be attached; other reels have flanges on their outer edge into which the film slots. Once the end of the film is in place, wind the rest onto the spiral groove in the reel. Practice with a length of old film in daylight first. Try not to touch the emulsion surface of the film with your fingers.

YOU WILL NEED

Equipment
Lighttight room or lightproof changing bag
Bottle opener
Scissors
Daylight developing tank
Rubber gloves
Thermometer
Clock with a second hand (optional)
Squeegee (optional)
Drying line and clips
Transparent storage pages for negatives

Materials
Developer
Stop bath
Fixer (hypo)
Wetting agent

3 Place the loaded spiral into the developing tank and screw the lid on. You can now turn the lights on (or remove the tank from the changing bag) and carry out the remaining steps under normal lighting conditions.

4 The temperature of the chemicals, particularly the developer, must be kept constant for the duration of the development stage – usually 68°F (20°C). It is worth filling a bowl with water at 68°F (20°C) and keeping the bottles of chemicals and the loaded developing tank in that for a while so that they are all at the same temperature.

5 Start the clock and immediately pour the developer (a weak alkaline solution) through the hole in the lid of the developing tank.

CAUTION
Put on a pair of rubber gloves before handling film-processing chemicals.

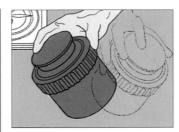

6 Put the cap on the tank and invert the tank three times. Then give the tank a sharp tap with the heel of your hand to dislodge any air bubbles from the surface of the film. Place the tank back into the water bath, and leave it for the recommended time. (For the rest of the process, you must agitate the tank regularly. A typical method is to invert the tank three times every 30 seconds.)

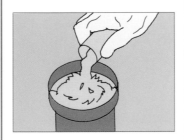

7 Pour the developer away and pour in a stop bath. The stop bath is a weak acid (usually acetic acid) that neutralizes the developer immediately and "stops" the process. Place the tank back into the water bath for about 30 seconds, remembering to agitate it as required.

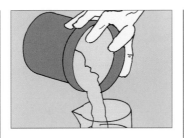

8 Pour the stop bath into its storage bottle and pour the fixing solution into the tank. The fixing process usually takes two to three minutes, after which you should put the fixer back into its storage bottle.

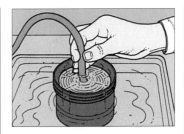

9 Wash the film in clean running water for a minimum of 20 minutes. The best way to do this is with a special hose that forces water up from the bottom of the tank, making sure that fresh water flows over the surface of the film.

FAULTS ON THE NEGATIVE

FOGGING
An ill-defined dark area on the negative indicates fogging of the film. Here, the fogging extends outside the frame area, suggesting that the film was fogged outside the camera.

BUCKLING
In this example, the processing chemicals have failed to reach part of the film, leaving it undeveloped. This is most likely due to the film being buckled in the spiral.

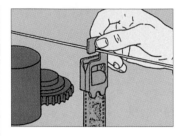

10 | Rinse the film in wetting agent (a mild form of detergent that helps the water to flow off the surface of the film without leaving drying marks).

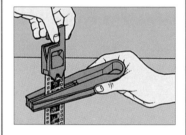

11 | Try to get as much water off the surface of the film as possible before hanging it up. Gently rub it through a special film squeegee, or even two fingers that you have wetted with the wetting agent.

12 | Choose a warm, dust-free area in which to dry the film. Hang the film from a line and attach a weight to the bottom of the film to prevent it from curling while it is drying.

13 | When the film is dry, cut it up into strips of six negatives, and store it in negative filing pages.

COLOR FILM PROCESSING Color film processing is almost exactly the same as black-and-white film processing, but has more stages. The timing of the stages, and their temperatures, are far more critical, usually to within half a degree. Temperatures too are generally higher than for black-and-white film processing, usually 100°F (38°C). Various small automatic processors are available that use electric thermostats for controlling the temperature. If you are going to do a lot of color processing, they may be worth the investment.

All color film processes convert the silver grains into colored dye, and then bleach away the silver, so that color negatives and transparencies are composed of dye rather than silver.

Color negative processing Normal color negative processing is known as C41. It consists of a color developer, bleach/fix stage, and final wash. You can buy the chemicals as a kit designed for home use. Carry out the same procedure as for black-and-white film, paying particular attention to the temperature. A couple of special black-and-white films, called chromogenic films, can be processed using the C41 process (see Film).

Color transparency film Almost all color transparency (slide) films use a process called E6. (The only exception is Kodachrome, which cannot be processed at home.) Like the color negative process, a kit designed specially for home use is available. The process is longer than for color negatives and includes a reversal stage, where the tones are reversed, so that a positive is obtained rather than a negative. During the first developer stage, the effective speed of the film can be altered by increasing or decreasing the development time. It is particularly important that the timing and temperature of this first stage is carried out accurately.

◄ EQUIPMENT AND MATERIALS
For color processing, it is essential to maintain the temperature of the chemicals precisely. Place all of the bottles in a deep plastic bowl, filled with water at the appropriate temperature. Color negative processing requires a color developer and a bleach/fix solution; color transparency processing needs two developers and a bleach/fix solution.

COLOR FILM PROCESSING

1 Load the processing tank with film in total darkness, as for black-and-white processing. Mix and pour measured quantities of the solutions into separate, clearly marked containers.

3 At the end of the developing time, quickly pour out the developer.

4 Pour in stop bath and agitate continuously for 30 seconds. Pour out and refill with fixer for the time recommended by the manufacturer. Follow the same procedure for every solution. Hold the tank at an angle to pour in the solution. Start the timer, then agitate the tank, as recommended, placing it in the water bath between agitations. Use the final 10 seconds of each stage to drain the tank.

5 When all processing and wash stages are over, empty the tank, take off the lid, and insert a hose from the cold water faucet into the core of the reel. Wash for at least 30 minutes in gently running water. Strong water pressure may damage the emulsion.

6 Before removing the reel from the tank, add a few drops of wetting agent to prevent drying marks. Attach the film to a hanger clip and gently wipe off any excess moisture. Hang the film to dry in a space free from dust and air movement.

2 Fill a deep container with water at about 110°F (44°C) and put the loaded tank and numbered graduates into it. Let stand for a few minutes, when all solutions are between 95° and 105°F (35° and 40.5°C). Check the temperature of the developer solution and pour it into the tank. When full, tap the tank to dislodge air bubbles, and fit the cap that covers the lid's central opening.

SAFETY GUIDELINES

■ Always use rubber gloves when handling film-processing chemicals.
■ Work in a well-ventilated area, and avoid inhaling chemical fumes as much as possible, particularly if you are mixing the developer from powdered chemicals. Fixer, or hypo, fumes in particular can cause irritation of the throat or lungs.
■ The fixer is a weak acid solution, and will damage clothes and other articles, so always wipe up any spills as soon as possible.
■ If any chemicals get into your eye, wash the eye with copious amounts of fresh water and consult a doctor.
■ You can re-use the stop bath and fixing solutions, but you should dispose of the developer once it has been used. In most cases you can dispose of it by pouring it down the drain, but check local by-laws regarding the disposal of photographic chemicals.
■ Be very careful when handling or disposing of color chemicals. Some of them are noxious.
■ Do be sure to check the instructions supplied with the various chemicals.

Printing Film

Producing prints from either black-and-white or color negatives is for the most part a similar process. In both, the light is projected through the negative onto light-sensitive paper in an enlarger. You have control over the density of the print (the brightness) by altering the amount of light that the paper receives.

With black-and-white film you can also alter the contrast of the print, and with color film you can adjust the overall color balance of the print.

BLACK-AND-WHITE PRINTING The printing process entails projecting the negative onto light-sensitive photographic paper using an enlarger. By varying the height of the enlarger you can produce prints of various sizes. Two further controls are possible. First, you can vary the brightness, or density, of the print by altering the exposure time and/or aperture on the enlarging lens. Second, you can vary the contrast by filtering the variable contrast paper with different colored filters.

The paper is not sensitive to red light, so you can work in a darkroom lit by red or orange safelights. Enlargers usually have red safelight filters built into them, so that you can project the image through the filter and onto the paper without exposing it.

Most photographic printing paper is variable contrast. The contrast is altered by using different combinations of filters in the enlarger. It is useful, although not essential, if the enlarger you are using has either "dial-in" filters built into the head, or has a filter drawer into which you place the filters. If it does not have these facilities, you can buy sets of filters together with a filter holder, which fits underneath the enlarger lens.

Exposing a test strip The first step when making an enlargement is to produce a test strip with a range of exposures. This will enable you to determine the correct exposure and contrast for the final print.

☞

**Darkroom design,
pages 92–93
Film processing,
pages 94–97**

THE ENLARGER

WARNING
When printing, never operate the enlarger or any other electrical device with wet hands.

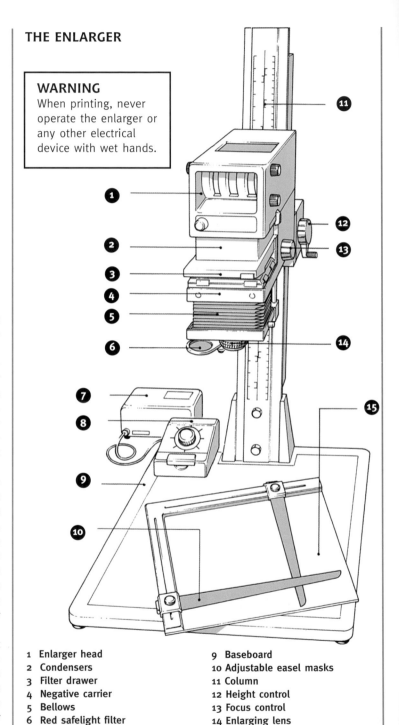

1 Enlarger head	9 Baseboard
2 Condensers	10 Adjustable easel masks
3 Filter drawer	11 Column
4 Negative carrier	12 Height control
5 Bellows	13 Focus control
6 Red safelight filter	14 Enlarging lens
7 Voltage stabilizer	15 Easel
8 Timer	

EXPOSING A TEST STRIP

1 | Place the negative in the enlarger's film carrier, then insert the carrier in the enlarger head.

2 | Adjust the height of the enlarger to give the required size of print.

3 | Focus the image, either by hand or by using a focusing magnifier, which allows you to check the sharpness of the film's grain (when the grain of the film is focused, you will have the sharpest print possible from your image).

YOU WILL NEED

Equipment
Enlarger with timer (preferably with dial-in color filters)
Focusing magnifier
Scissors, or rotary print trimmer
Masking easel
Safelight (red or orange)
Contact frame or sheet of glass
Processing dishes, large enough for the print sizes you are making
Print tongs, or rubber gloves

Materials
Printing paper
Print developer, stop bath, and fixer
Print dryer or drying rack

4 | Dial in the appropriate filters to give an average contrast (see the manufacturer's leaflet), and stop the lens down three stops, which will allow you to use reasonably short exposure times.

5 | Under safelight illumination, insert a sheet of printing paper, emulsion-side up on the easel, then expose the paper for 5 seconds. Cover a quarter of the sheet of paper with a piece of opaque card and give the rest of the paper another 5-second exposure.

▼ ASSESSING TEST STRIPS
The 5-second exposure on this test strip is too light, while the 15- and 20-second exposures are too dark. The 10-second step is almost right, though perhaps a fraction dark.

6 | Repeat this twice more by covering half and then three-quarters of the paper. The strip of paper will now have received four exposures in the following steps: 5, 10, 15, and 20 seconds. Process the strip (see pages 101–102) and assess (see below).

7 | The required exposure level and contrast settings can now be applied to a full print. When producing prints, try to arrange for a final exposure in the region of 12–15 seconds. This will make it easier to carry out any necessary dodging or burning.

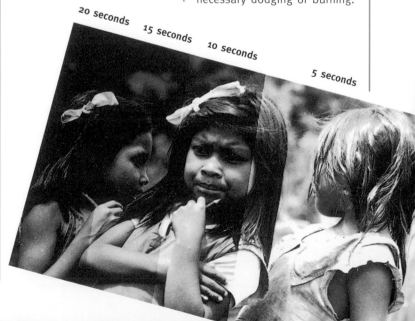

20 seconds 15 seconds 10 seconds 5 seconds

DODGING AND BURNING

1 Areas of the print can be shaded by hand for a couple of seconds to lessen exposure in those areas while increasing exposure in others.

2 A variety of shading tools can be used to help accentuate shadows in the desired areas.

3 Try using cupped hands to control the size of the area being exposed during the printing process.

Dodging and burning When you make a print you may find that some areas need more or less exposing than the main exposure. You can make adjustments to certain areas of the print either by dodging (decreasing the amount of exposure) or burning in (increasing the amount of exposure).

To "dodge" areas, stick a piece of opaque card onto thin wire and use this to mask areas of the print during the main exposure. Burning in can be achieved by cutting appropriately sized holes in opaque card to allow areas of the print to receive more than the main exposure. Alternatively, use your hands as tools for dodging and burning. It is important that whenever you dodge or burn prints you keep the mask, or your hands, moving at all times to avoid getting a line around the dodged area.

Variable contrast paper and filtration The contrast of most modern printing papers is altered by a combination of magenta and yellow filters, through which the enlarger light passes. The higher the amount of magenta filtration, the higher the print contrast. Different papers, filters, and enlargers give different results, so read the manufacturer's instructions carefully. A typical filtration, to give an average contrast print from an average negative, might be in the region of 50M and 50Y.

Assessing your work Prints look slightly different when they are wet than when they are dry, so try to take this into account when assessing them. Look for a good rich black tone, a good clean white tone, and a full range of tones in between. Prints that are too light require more exposure, while prints lacking contrast need to have the contrast of the paper increased. Judging the final density and contrast of a print is an art that will take some time to master. Remember, not every photographer will like the same type of print, so produce prints that you like. However, if you look at other photographers' work you will see the quality that it is possible to achieve.

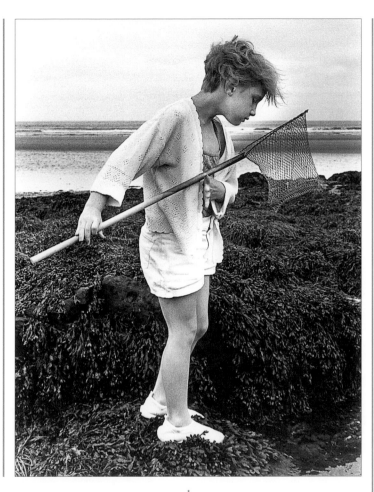

PROCESSING BLACK-AND-WHITE PRINTS

PROCESSING BLACK-AND-WHITE PRINTS The processing procedure for black-and-white prints is similar to that for film, with a developer, stop bath, fixer, and wash. You will need three processing trays, plus a means of washing the prints. The trays should be just larger than the prints you are going to produce. Wear rubber gloves or use special print tongs when working.

Contact prints If you want to see how a whole roll of film will look when converted to positive prints, you can make a contact print from the negatives. This is where the negatives are placed in contact with a piece of printing paper to give a series of prints the same size as the negative. This is a very quick way of determining which negatives you want to enlarge.

◄ ▲ BURNING IN
The tones of the child's clothing and face, and also the background, were too light on the first, "straight" print (left), so they have been "burned in" for an extra 20 percent to darken them (above) – that is, exposed for 20 percent longer than the other areas of the print. This produces a much more balanced and attractive print.

1 | Pour print developer into the first tray to a depth ½in (13mm) or so. The temperature of this solution should be held constant at around 68°F (20°C). Put the stop bath in the next tray (you can use water as a substitute if you wish), and the fixer in the third tray. If you use color-coded trays, you can use the same tray each time you process prints.

2 | Immerse the exposed paper in the developer emulsion-side up, and immediately rock the dish back and forth to make sure that the paper is covered evenly. The time for development will vary, depending on the developer you use, but will be in the region of two to three minutes. Never underdevelop your prints, or you will not achieve a good rich black tone. (If the print is too dark, give it less exposure, or stop down the lens more.)

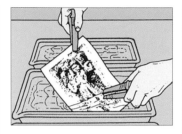

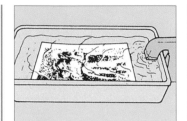

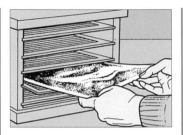

3 | The image should start to appear after around 15–20 seconds. When the print has received the correct amount of time, lift it by a corner and allow the developer to drain from the paper for a few seconds before pushing the print into the stop bath.

4 | Rock the dish for a few seconds before transferring the print to the fixer. The amount of time the print remains in the fixer depends on the type of fixer you have used, so read the manufacturer's instructions. When the print is ready, you can turn on the lights to inspect it.

5 | When you are satisfied that the print is of the right density and contrast, wash and dry it. You can buy print washes, but you will achieve the same result if you run a hose over the surface of the print for about five minutes. This applies to modern resin-coated (RC) papers. If you use fiber-based papers – used mainly for exhibition work – you will need to wash them for a minimum of 20 minutes to remove all traces of chemical from the paper fibers.

6 | RC papers will dry flat if you leave them on a flat surface, or you can construct a simple print drying rack, with several pull-out shelves. You might want to buy an automatic print dryer, but they are expensive.

CONTACT PRINTS

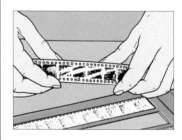

1 | Place all of the strips of negatives emulsion-side down (the side that has a matt finish toward which the film curls) in the glass cover of the contact frame.

2 | Place the frame under the enlarger so that the illumination covers the area of the frame. Place a sheet of printing paper, emulsion-side up, underneath the negative strips and close the glass cover of the frame.

3 | Stop the lens down to around f8, then process the print as usual.

▶ ASSESSING CONTACTS
A contact sheet is an excellent way to determine the best frame to print. Mark them with special wax pencils or fiber-tipped pens.

▶ COLOR TEST STRIP
This color test strip has been exposed for 5, 10, 15, 20, and 25 seconds. A final exposure of 17–18 seconds would produce a good print from this particular negative.

COLOR PRINTING There are two main types of color printing: printing from color negatives, and printing from color transparencies. The two controls available are that of density and color. The room in which you work has to be much darker than it is for black-and-white processing. Color paper is sensitive to all colors, therefore the safelights available for color printing tend to be very dim.

As in color film processing, the timing and temperature of color print processing are far more critical than they are for black-and-white prints, and it may be worth investing in an automatic print processor. The processor should contain a thermostat, and use a minimum number of chemicals for each print, automatically discarding the chemicals after use. If this is not possible, use a print drum.

Using a print drum When carrying out this procedure, make sure the water and all chemicals are at the correct temperature (see Film Processing). Refer to the manufacturer's instructions for developing time.

25 seconds 20 seconds 15 seconds 10 seconds 5 seconds

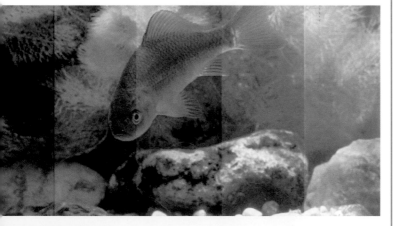

USING A PRINT DRUM

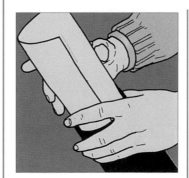

1 Working in a room with a safelight suitable for color printing, roll up the exposed paper with the emulsion side on the inside and load it into the drum. Put the cap on the drum. Once you have done this you can work in normal light.

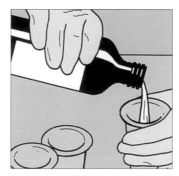

2 Pour all of the solutions into dispensers. Place these and the drum into a bowl, and pour hot or cold water to the bowl until the solutions are at the recommended temperature. Pour the developer into the print drum, then put the cap back on the drum.

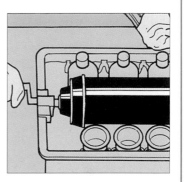

3 Agitate the solution by revolving the drum for the required length of time. Just before the end of the recommended time, start to discard the developer. If necessary (instructions vary) add the stop bath to the drum and roll the drum as before. When finished, pour off the stop bath and add the bleach/fix solution.

4 Pour off the bleach/fix solution and remove the print. Wash it thoroughly and hang it up to dry.

► FILTRATION TESTS

Once you have correctly exposed the print to achieve the right density, you will need to adjust the color if your first test has an overall color bias, or "cast." Use the table opposite to help correct it. The strips of different color filtrations (opposite page) show the effect of various filters (using the correctly balanced print as the departure point). Such strips can be helpful when assessing filtration.

Red bias

Green bias

Yellow bias

Printing from color negatives The main difference between this and black-and-white printing is the adjustment of color balance. You will need a set of yellow, magenta, and cyan filters for adjusting the color. Many enlargers have these built in as dial-in filters, and if you are buying an enlarger specifically for color printing, try to get one that has this feature.

Different papers, chemicals, and enlargers will all have their own distinct characteristics, so it is not possible to give rigid guidelines. However, start your first tests with a filtration of 50M and 50Y. You might like to add an extra element to the test strip, and on a square sheet of paper, produce an exposure test in one direction and a color test in the other direction. This will result in a grid of squares of different densities and colors. Make careful notes.

Changing the filtration, either by adding filtration or subtracting it, will affect the exposure. Again, you will need to test it, but as a rule of thumb, for every 10 units of magenta filtration you add or subtract, you will need to add or subtract 15 percent to or from the exposure time. Adding or subtracting yellow filtration usually has very little effect on the exposure.

When making any type of color print, it is important to get the density of the print right before worrying too much about the color. Changing the density will affect the overall color of the print to some degree. Also, the color and density of the print will be different when the print is dry, so it is worth drying the tests before assessing the color and density. If you do not have a print dryer, then hang prints from a line with pegs, and use a hair dryer to dry them.

When assessing the tests for color balance, you can use special viewing filters. These are sets of colored filters through which you view the prints. If the print looks fine through a magenta filter, then you will need to add magenta filtration.

Correctly balanced

10 blue 20 blue

10 green 20 green

10 red 20 red

10 yellow 20 yellow

10 magenta 20 magenta

10 cyan 20 cyan

COLOR ADJUSTMENT

With color negatives, the paper reproduces the colors projected onto it in reverse, so a cast is corrected by increasing the strength of filtration in the same color as the cast, or by reducing filtration of the cast's complementary colors. In color transparency printing, the paper reproduces the same colors projected onto it, so a color cast is corrected by reducing filtration in the same color, or increasing it in the cast's complementary colors. For most color printing, you only need to use the magenta or yellow filtration (you should never use all three filters). The combination of filters that you use is known as a filter pack. The adjustments below refer to color negative printing; to adjust color slide prints, simply do the opposite.

If your print is too red	Remove equal amounts of yellow and magenta
If your print is too green	Remove magenta
If your print is too blue	Remove yellow
If your print is too magenta	Add magenta
If your print is too cyan	Add equal amounts of yellow and magenta
If your print is too yellow	Add yellow

Printing from transparencies There are several methods of producing prints from transparencies: making an inter-negative, which is then printed normally using R-type reversal paper; and the Cibachrome process, which is the most common outside the professional lab. For this you need Cibachrome paper and chemicals and, preferably, an automated print processor to ensure consistency. One major advantage that Cibachrome has over conventional color printing is that the prints are virtually fade-resistant, whereas normal color prints will fade over time.

The Cibachrome process itself is similar to the normal color print process; the major difference is in the exposure and correction of color balance. Since it is a reversal process, if you want to make the print lighter you give more exposure, and vice versa. Also, the filtration works in the opposite way to that given in the color adjustment table above. So, for example, if your print has a magenta cast, then you take magenta away from the filters you have used, and so on.

Retouching & Coloring Prints

The production of prints is not necessarily the end of the processing procedure. There are a number of techniques that you can use on a finished print, some of which may be necessary to produce a fine result.

For example, you may need to retouch in order to remove any dust specks or scratches transferred from the negative. You may want to tone black-and-white prints to give a sepia or copper color to mimic old photographs, or hand-color a print by brushing watercolor onto the surface.

RETOUCHING Although it is possible to retouch negatives, it is much easier to work on larger prints. If you make a mistake, you can always make a new print. There are two basic types of retouching that you will need to carry out on most prints: retouching white specks or scratches, and retouching black ones.

► EQUIPMENT AND MATERIALS
You will need a range of dyes, paints, brushes, some water, and absorbent cotton. Always test colors on a sheet of paper of the type you are going to retouch before touching the actual print.

Darkroom design,
pages 92–93
Film processing,
pages 94–97

RETOUCHING

1 White specks and lines are probably the easiest items to retouch, as the aim is to fill them with a tone that matches the surrounding area. Mix the dye or paint on the edge of a spare piece of printing paper, so that this can be butted up to the spot to enable you to match the tone. Do not attempt to paint in a scratch; instead, hold the brush vertically and dot it with a series of spots. A stippled finish will merge in with the rest of the print better than a painted line.

YOU WILL NEED

Equipment
High-quality sable retouching brushes in various sizes
Scalpel or craft knife
Magnifying glass

Materials
Retouching dyes (black and gray for black-and-white, color dyes for color prints)

2 You can remove black spots and blemishes either by chemical bleaching or "knifing" them with a sharp blade. Using the very tip of the blade, scrape gently at the top layer of the paper. This will leave a white area, which you can spot as described in step 1. Take care when using the knife.
For spotting color prints, use the same method as for black-and-white, but you will have to match the colors of the dyes in the surrounding areas exactly. You can buy sets of colored dyes that can be mixed together to produce other colors.

◀ BLUE TONING
This gives black-and-white prints a very different quality, and often produces a stark effect, as in this portrait.

▶ SEPIA TONING
Sepia tones give an old-fashioned, romantic look to a print, which complements this soft focus portrait perfectly.

▼ HAND-COLORING
This is great fun to do, and almost every print produced will be unique, so you can create several different versions of the same picture.

TONING PRINTS Black-and-white prints can be toned a variety of colors, including sepia, copper, and blue. You should be able to buy the toners in a kit that includes instructions. For sepia toning, you need to start with a well-developed image full of tone.

HAND-COLORING This technique is not a substitute for color photography, but it can be used for more creative work. Many photographers working in the 1920s and 30s hand-colored their photographs. The basic materials you will need are a range of good-quality sable brushes and appropriate dyes (photo-tint dyes) or paints. Matte surfaces work best, and it is advisable to choose a print that does not have too many dark tones. You could try a sepia tone first, and then hand-color parts of it. It may help to have a spare copy of the print to test the color before applying it to the one you are working on.

To hand-color your prints, first bleach the print to remove most of the image. This will leave a weak, straw-colored image. Redevelop the print in the toning solution, then wash and dry it thoroughly. If you only want to tone certain areas, you can either paint the bleach and toning solutions onto the appropriate areas of the print, or use waterproof masks to mask those areas that you do not want to tone.

Storage & Presentation

It is obviously vital to store your negatives, transparencies, and prints safely and carefully to keep them in good condition, particularly if you plan to display your work. In addition, the way in which you present your photographs can be as important as the photographs themselves.

Careful storage and presentation are especially important if you are exhibiting or preparing a portfolio to be shown to potential clients. Think carefully about the best method of presentation for the purpose you have in mind.

CHOOSING A MOUNT When choosing a mount for the photograph, consider the background tone or color and the texture of the mount. Color prints in particular do not usually work well when mounted on colored card; the color of the card may detract from the color of the print. Black, white, or gray is often a better choice. If you are planning a wall display with a number of images, try to choose the same color card for all of the prints.

MOUNTING PRINTS If you are mounting prints onto card or paper, there are a number of adhesives suitable for the purpose. Heat-sensitive tissue, for which you need a heated press, is perhaps the best, but most expensive, method. Other possibilities include spray adhesives, rubber cement, and PVA glue. Another option is double-sided tape, which can be bought in sheets and rolls. Try to use the sheets if you can, as a line may form on the front of the print from the edge of the strips.

Spray adhesives are usually available in two forms, one that allows you to re-position the print before finally sticking it down, and one that does not. (The fumes from some adhesives can be an irritant: use only in a well-ventilated room.)

WINDOW MOUNTS A window mount is usually rectangular, although it can be circular or elliptical. For the best results, the window should have beveled edges, for which special cutters are available. These give a professional appearance to the mount, although it takes practice to achieve the best results.

WINDOW MOUNTING A PRINT

1 Using a pencil and steel ruler, lightly mark the picture area that is to appear when mounted. Make sure that the margins are equal.

2 Mark these dimensions on the back of a sheet of thick cardboard, and using an angled mat cutter, cut each of the lines up to the corners. Trim the edges if necessary.

3 On a second sheet of cardboard – the backing for the mount – position the print and mark around the edges in pencil.

YOU WILL NEED

Equipment
Pencil and steel ruler
Angled mat cutter
Roller

Materials
Mounting board
Spray adhesive, rubber cement, or PVA glue

4 Spray the back of the print lightly with adhesive, or coat with rubber cement or PVA glue. Turn the print over and position it carefully along the drawn lines on the back piece of the mount. When the print is in place, press it onto the mount using a roller.

5 Place the front piece of the mount on top of the print, aligning it carefully. Press it down firmly.

◀ COLOR CHOICE
This photograph of a camel has been mounted on a neutral gray card to avoid a clash with the colors in the image. Note the larger space at the bottom of the print to provide balance.

▶ DOUBLE AND TRIPLE MOUNTS
Some photographs are enhanced by using mounts composed of two or three layers of cardboard. These can provide frames with greater depth, color, and decorative possibilities. There are many options, for example: a simple square in each corner (top); a pattern of cuts revealing a different-colored mount below (center); a combination of angular and curved edges (bottom).

▲ ▶ FORMAT
The landscape above has been cropped to a thin, horizontal frame, perfectly suiting the composition of the image. The portrait mount of the seascape on the right helps to draw the viewer into the scene toward the horizon.

MOUNTING TRANSPARENCIES If you are going to project your transparencies, you can protect them with glass mounts (preferably of the "anti Newton-ring" type). However, if you are sending transparencies through the mail, they must be transferred to glassless mounts in case of breakage. Place these in transparent or semi-transparent transparency bags or envelopes to protect them from damage.

You can buy sheets of black card with pre-cut windows to display groups of 35mm and transparencies of other sizes in portfolios. They come in different sizes for holding various numbers of transparencies. The mount should be placed in the acetate sleeve that is sold with the mount. This has a translucent backing, which gives an even illumination when the transparency is held up to the light.

PORTFOLIOS If you need to show a number of your photographs to clients such as publishers, a portfolio is the usual form of presentation. Portfolios come in a number of standard sizes, from A4 to A1 and larger, although A3 is usually large enough for most work. The photographs are mounted on card or paper in acetate sleeves. Think of the folio as a book, and plan the design as double-page spreads, so that when it is opened flat, the two pages seen together act as an integrated, balanced design.

HOME-MADE BOOKS Another way of displaying prints is to make home-made books. You can choose the paper, size, and theme of the book, and if you have access to desktop publishing facilities, you can design the cover and the inside pages.

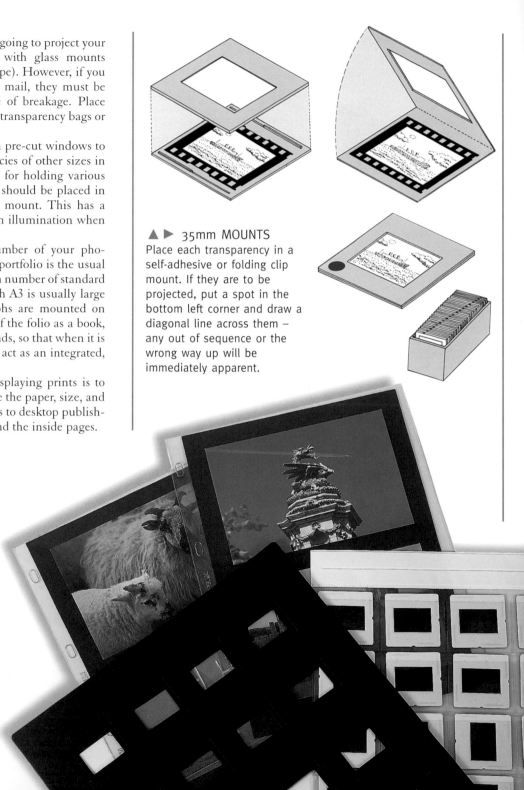

▲ ▶ 35mm MOUNTS
Place each transparency in a self-adhesive or folding clip mount. If they are to be projected, put a spot in the bottom left corner and draw a diagonal line across them – any out of sequence or the wrong way up will be immediately apparent.

▶ STORAGE SHEETS
Color transparencies should be sorted on a lightbox, then kept in some form of storage sheet. Shown here are a 35mm suspension file for use in a standard filing cabinet, a black card with 35mm apertures for holding 20 slides, and acetate sleeves for larger format transparencies.

▲ CLIP FRAMES
These are easy to use and inexpensive. Place a mount that is the same size as the glass over the print.

▶ WOODEN FRAMES
Wooden frames are good for displaying shots of people. Be careful that the mount is not overpowering, though.

INDIVIDUAL FRAMES Framing photographs for wall or free-standing display can show off the pictures to their best effect. There is a wide range, from frameless clip-mounts to highly ornate wooden or metal frames. Choose a frame that is appropriate to the subject, and one that will not detract from the photograph itself. You can buy ready-made frames or frame kits to make up yourself. Choose non-reflective glass if you can, and arrange for a bright but glare-free lighting on the print.

EXHIBITIONS One of the great thrills for photographers is to have an exhibition of their own work. This should be planned very carefully, and a great deal of thought given to the choice of pictures and their juxtaposition. Pictures should be at eye level, with plenty of space between them. Inspect the venue carefully, and decide if you want visitors to view the prints in a particular order. Try to have a variety of work and print sizes, perhaps with large prints at the start and end of walls or gangways.

▶ METAL FRAMES
These are available in both modern, contemporary designs and in more ornate, classic styles.

DIGITAL IMAGING

THE PROCESSES OF PHOTOGRAPHY, SUCH AS DEVELOPING AND PRINTING, ARE RAPIDLY BEING REPLACED BY DIGITAL TECHNOLOGY, WHERE THE COMPUTER IS USED TO CARRY OUT ALL OF THE TECHNIQUES TRADITIONALLY PERFORMED IN A DARKROOM. MANY DIGITAL CAMERAS ARE ABLE TO GIVE RESULTS THAT ARE VIRTUALLY INDISTINGUISHABLE FROM THEIR FILM COUNTERPARTS. THE INCREASE IN THE QUALITY OF DIGITAL IMAGING, ALLIED WITH DECREASING COSTS, HAS BEEN EXTREMELY RAPID OVER RECENT YEARS, AND NO ONE INVOLVED IN PHOTOGRAPHY TODAY CAN AFFORD TO IGNORE IT.

Hardware & Software

The basic process of photography – exposing light-sensitive film, and processing and printing using wet chemicals – has remained largely unaltered for over a century. However, in the last five years or so, enormous technical advances have taken place that could signal the end of silver-based film and chemical processing.

Electronic cameras and computers are increasingly being favored over traditional photographic film and processing techniques (digital video cameras are also available, but these are beyond the scope of this book). Digital images can be obtained either by shooting pictures on digital cameras or by scanning photographic negatives, prints, or transparencies into the computer. The images can then be manipulated in many different ways if required, and output in a variety of formats. To work in this area of photography, you will need a certain amount of hardware and software specific to digital imaging.

ANALOG IMAGES Conventional photographs, based on the silver halide process, are analog images. In other words, the information in a conventional photograph consists of continuous tonal variations from black to white – the amount of detail is limited only by the size of the grains of silver (see Film).

☞
Cameras, pages 10–15
Film, pages 22–25

ANALOG–DIGITAL SAMPLING

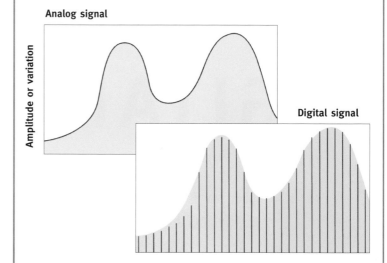

Analog signal

Amplitude or variation

Digital signal

▲ Conventional photographs are analog images, and this analog information has to be converted into digital data before it can be recognized by a computer. This is carried out by "sampling" the continuous analog data at intervals and analyzing the value of that data at various points. If this is done at frequent enough intervals, a good representation of the original data will result.

FROM ANALOG TO DIGITAL Digital images are made up of a regular pattern of dots (light-sensitive picture elements called pixels). Each dot has a binary number corresponding to a brightness level. A color digital image consists of a regular pattern of these dots covered in turn by red, green, and blue filters. A computer can read the binary data stored in a file and show the image on a screen or send it to a printer.

The process of digitization "samples" the analog information, and converts it into binary data that the computer can interpret. This is an electronic process that takes place either inside the camera or in a scanner.

COMPUTERS FOR IMAGING Although there are one or two digital cameras on the market that can be connected directly to printers, you will almost certainly require a computer for digital imaging purposes. The computer should have certain specific features: a reasonably fast, powerful processor (CPU) such as, at least, a 233 MHz Pentium II; as much memory (RAM) as you can afford (a minimum of 64Mb is recommended); a large hard disk; a CD ROM drive; and a good-quality monitor. You will also probably want some form of printer, of which the ink jet is now by far the most popular for home use.

THE IMAGING CHAIN

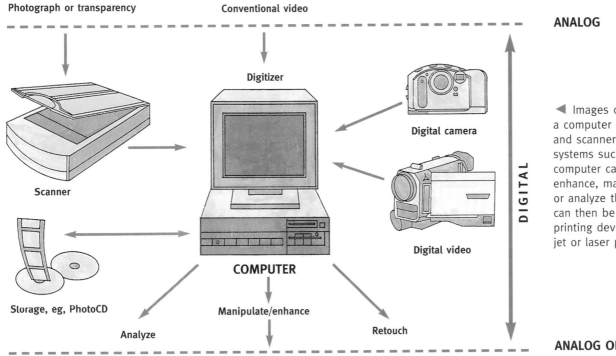

Photograph or transparency

Conventional video

ANALOG

Digitizer

Digital camera

Scanner

Digital video

DIGITAL

◀ Images can be input into a computer via digital cameras and scanners, as well as systems such as PhotoCD. The computer can then be used to enhance, manipulate, retouch, or analyze the images, which can then be output to various printing devices, such as ink jet or laser printers.

COMPUTER

Storage, eg, PhotoCD

Analyze

Manipulate/enhance

Retouch

ANALOG OR DIGITAL

Output, eg, laser print, thermal print, ink jet print, film, Internet/email

▼ COMPACT DISKS

CD ROMs have become an important way of storing digital images. PhotoCDs are relatively cheap to buy, and offer excellent quality at various resolutions.

You can use a digital camera or scan photographs – as negatives, transparencies, or prints – to get images into the digital format that the computer will recognize. If you do not want to go to the expense of buying a camera or scanner, you can have PhotoCDs (see page 117) made relatively inexpensively from conventional film.

IMAGING SOFTWARE You will need an image processing program to open and process your images. These range in price from nothing (there are several programs available on the Internet that can be downloaded free of charge) to several hundred dollars or pounds. Typical examples of relatively inexpensive programs are Adobe Photo Deluxe, Microsoft Picture It, and MGI PhotoSuite. The current industry standard is Adobe Photoshop, which is available for both PC and Apple Macintosh computers. Windows 95 has an imaging program as an accessory (Imaging for Windows), although this will only allow you to open and view images, not retouch or manipulate them.

DIGITAL CAMERA

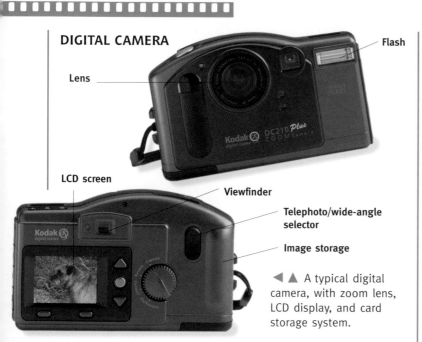

- Flash
- Lens
- LCD screen
- Viewfinder
- Telephoto/wide-angle selector
- Image storage

◀▲ A typical digital camera, with zoom lens, LCD display, and card storage system.

CHARGE COUPLED DEVICE (CCD)

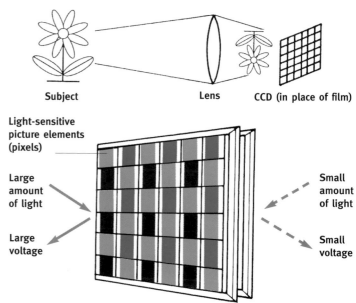

Subject — Lens — CCD (in place of film)

Light-sensitive picture elements (pixels)

Large amount of light

Large voltage

Small amount of light

Small voltage

▲ A CCD is a silicon chip, containing many thousands or millions of light-sensitive pixels, which generate an electrical current in proportion to the amount of light falling upon them.

DIGITAL CAMERAS Digital cameras are similar to film cameras: they have a lens, with associated aperture, and a shutter that controls the amount of light entering the camera. The major difference is that the film is replaced by a light-sensitive silicon chip, usually a CCD (Charge Coupled Device), although increasingly other chips, called CMOS (Complementary Metal Oxide Semiconductor) are being used. The CCD is a small rectangular silicon chip containing many thousands or millions of light-sensitive picture elements, or pixels. Light falling on the pixels causes it to generate an electrical voltage. The more light, the greater the voltage. The voltage is converted into digital data to be read by the computer. In general, the more pixels the CCD contains, the better the quality, or resolution, of the final image.

Color is created by coating each individual pixel with a red, green, or blue transparent filter. Digital cameras with "megapixel" CCDs (those with a million or more pixels) are common, and will give results comparable to conventional film images if they are not enlarged too much. As a guide, cameras with 1.3 million pixels will give prints of up to 7x5in (18x13cm) at photographic quality, although this is subject to a number of different factors. The figures quoted for CCDs will either show a total number of pixels (for example, 460,000 or 1.3 million) or two figures (for example, 640x480 pixels or 1024x1536 pixels).

SCANNERS There are basically two types of scanner: those designed for scanning film, either negatives or transparencies; and print scanners, for scanning photographic or other types of print. The latter are known as flatbed scanners (for some flatbed

FILM SCANNER

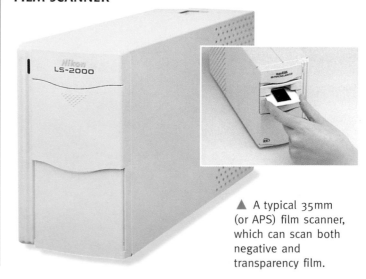

▲ A typical 35mm (or APS) film scanner, which can scan both negative and transparency film.

scanners you can add transparency units so that they can scan film as well). Scanners usually have a "linear CCD," which is a single row (or three rows, one for red, one for green, and one for blue) of pixels on a movable bar that scans the image area. A scanner's resolution is dependent on the number of pixels in the row. If the row is 8in (20cm) wide, and has 2,400 pixels, then the resolution is 300 pixels, or dots, per inch, which is probably adequate for most prints. For film such as 35mm, you will need a resolution of around 2,000 dots per inch to achieve high-quality prints.

PhotoCD PhotoCD is a proprietary system by Kodak, and enables high-quality scans from 35mm negatives or transparencies at a very reasonable cost. (Other types of PhotoCD, such as Pro-PhotoCD, are designed for medium and large format originals.) The finished disk can hold up to 100 images, each of which is stored at five different resolutions for different uses. If you want the very highest quality for printing, you choose the highest resolution, 18Mb. If you need images for inclusion in an Internet website, then you would choose a much lower resolution.

FILE FORMATS Once you have some digital images, either from a camera or scanner, you need to save them. You will have a choice of "file format," and the one you choose will largely determine not only the size of the stored file, but also what you can do with the image. The most common formats are TIFF (Tagged Image File Format), and JPEG (Joint Photographic Experts Group). Both of these are "cross-platform," in that they can be transferred from PC to Macintosh computers if necessary.

FLATBED SCANNER

▲ A typical flatbed scanner for scanning prints or other artwork.

EXPERIMENTING WITH IMAGE RESOLUTION

LOW RESOLUTION
This picture is composed of a relatively small number of pixels, which become visible when the image is enlarged to any extent. This image is 50Kb in size.

HIGH RESOLUTION
This image has many more pixels, and is of "photographic" quality, without any visible pixels. The more pixels an image has, the larger the file size: this file is 15Mb in size.

TIFF files TIFF files are universal, and most imaging programs, as well as presentation programs such as Powerpoint, and desktop publishing programs such as Pagemaker, can recognize them. When saving the file you can choose to compress the data, using "LZW" compression. This will reduce the size of the stored file by around 50 percent without any loss in quality.

JPEG files JPEG is a file format specifically for compressing images. Again, it is cross-platform, but data will be lost during the compression process. You have a choice regarding how much to compress your image. High compression gives a small file, but relatively low quality. You can achieve compression ratios of up to 100:1 with JPEG. You need to do some tests to check the settings you are happy with. If in doubt, use the TIFF file format.

Image Capture

Shooting pictures with digital cameras is fundamentally no different from shooting pictures with film cameras. The majority of digital cameras are similar to compacts, in that they have a direct vision viewfinder, so you need to take account of parallax when shooting close-ups.

In some digital cameras the viewfinder has been replaced with an LCD television screen, on which the image is viewed and composed. This can be difficult to see in sunny conditions. The chips used in digital cameras are smaller than 35mm film, so the lenses used in digital cameras are correspondingly shorter. The standard for many cameras will be in the region of 16mm. A typical zoom lens would have focal lengths from 8–24mm (which is the equivalent of 38–115mm in 35mm film cameras).

BATTERIES One of the biggest practical problems with digital cameras concerns the batteries. Many will only allow perhaps 50 or so shots on a set of batteries, and some, particularly those with LCD displays, use the batteries much more rapidly than that. It is essential to have spare batteries at all times. You can use rechargeable batteries, although these never give as many shots as conventional ones.

IMAGE STORAGE The other factor to consider is image storage. Most cameras use one of a range of removable cards. There are various types, including PCMCIA or PC cards, and SmartMedia and CompactFlash cards. All of these have differing capacities, from 2–270Mb, which will govern how many images you can take before the storage cards are full. At least one model uses standard 3.5in floppy disks.

☞
Cameras, pages 10–15
Close-up photography, pages 46–51
Hardware and software, pages 114–117

▶ REVIEWING IMAGES
Many digital cameras have LCD screens on the back for reviewing shots. There are usually options for deleting or filing images. Beware: the use of LCDs can quickly drain the camera's batteries.

▶ MEMORY CARDS
Various types of storage device are available for digital cameras, including Compact Flash and Smart Media cards. They are available in different sizes. Many can be plugged directly into card readers in laptop or desktop computers.

Storage cards hold a certain number of images, after which those images either have to be downloaded into a computer, or the card has to be replaced with another one. The cards themselves can be reused, so you will probably need only two or three cards. Many professional photographers who use digital cameras carry portable laptop computers into which the images can be downloaded from the card. On those cameras with LCD displays, the images can be reviewed seconds after they have been taken, and those not needed can be deleted immediately, freeing space on the card.

IMAGE QUALITY Many digital cameras give options for image quality, with settings such as good, better, and best. You will get fewer best-quality images on a disk than good ones, but wherever possible use the "best" setting. The other settings compress the data in order to make the images smaller for storage, but in doing so degrade the image quality.

▶ DOWNLOADING You can download images from cameras or scanners onto a laptop computer, which can be fitted with a modem. You can then transmit images anywhere via a telephone network.

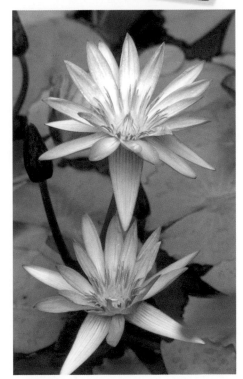

EXPERIMENTING WITH QUALITY SETTINGS

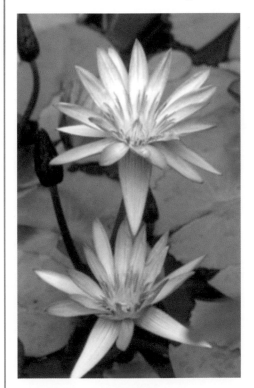

"GOOD" SETTING This image was captured on digital camera at "good" quality, and is 729Kb in size.

"BETTER" SETTING This image was captured at "better" quality, and is 1.96Mb in size, just under three times larger.

"BEST" SETTING This image was captured at the "best" quality setting, and is over 5Mb in size.

Image Processing

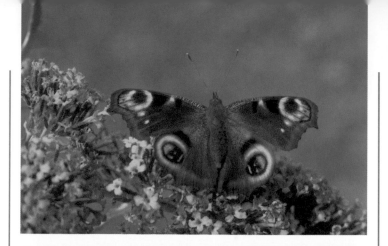

The computer is sometimes referred to as the daylight darkroom, because most of the processes carried out in darkrooms can be replicated using image processing software. This includes adjustment of brightness, contrast, and color balance, retouching, toning, and hand-coloring.

In addition, the computer can perform a wide range of other image enhancements and manipulations that would be almost impossible to achieve in the traditional darkroom. Image processing can be divided into image enhancement, in which images are improved and prepared for printing, and image manipulation, in which images are fundamentally altered in some way. Scientific and technical photographers also use the technology to analyze images.

ENHANCING BRIGHTNESS AND CONTRAST The most common enhancement you will need will probably be that of altering the brightness and contrast of the image. All image processing programs allow you to do this, either with simple slider controls or by using a curved control, which allows very fine tuning of shadows and highlights.

COLOR ADJUSTMENT Like the brightness and contrast commands, there is a variety of different ways of adjusting either the overall color balance of an image, or just a specific area of it. Simple sliders, which follow photographic printing principles, are found in all programs.

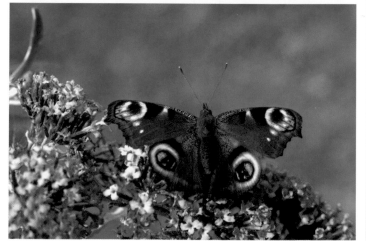

☞
Retouching and coloring prints, pages 106–107

EXPERIMENTING WITH BRIGHTNESS AND CONTRAST

The original image (top) has been scanned from a 35mm transparency, and is rather flat (low contrast) and too bright. Using the sliders (right, above), the image has been darkened and the contrast increased. Notice how the colors seem much more vibrant (saturated) in the enhanced image (above). The same effect could have been achieved using the curve control (right, below), whereby contrast can be increased by manipulating the angle of the central area of the curve.

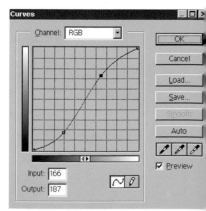

EXPERIMENTING WITH COLOR BALANCE

The original image of the parrot was too yellow (right), so blue was added to the image to correct it (below right). Sliders were used to do this (far right), but many programs have more sophisticated controls, including the "variations" box in Adobe Photoshop (below), which allows you to see the effect on the whole image of changes both in color and density. Using either method, the changes can be made to the whole image, or just to the shadow areas, midtones, or highlights.

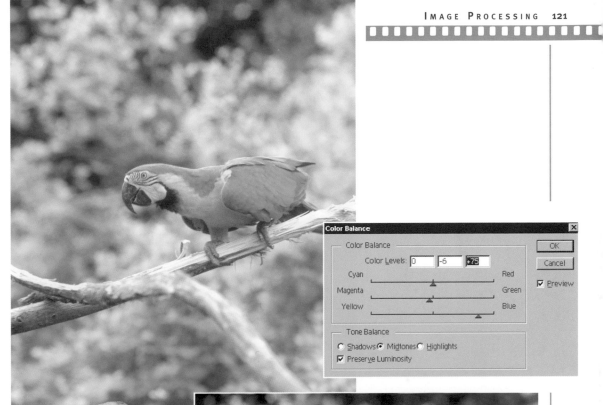

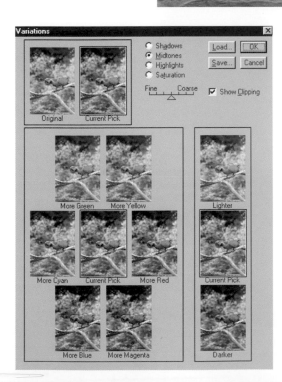

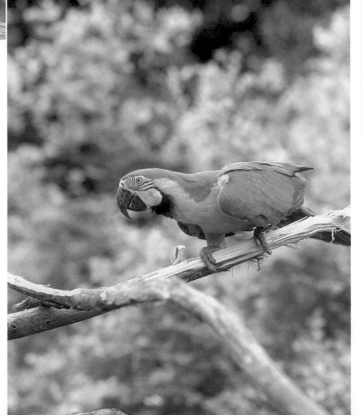

EXPERIMENTING WITH THE UNSHARP MASK FILTER

As can be seen in these images, you can adjust the amount, radius, and threshold of the unsharp mask filter (below). Here, the original image (right) is shown with the unsharp mask filter (USM) applied at various percentages. The filter works by increasing the contrast of pixels at tonal boundaries, or edges, within the image. The amount controls the overall effect of the filter; the radius governs how many pixels on either side of the "edge pixels" are sharpened; and the threshold governs at which point on the tonal range of the image the filter starts to work.

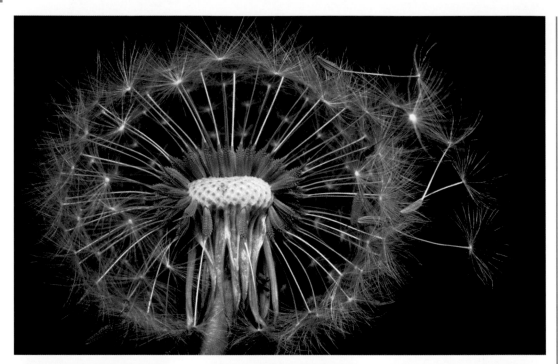

"Raw" image

USM 100%

USM 200%

USM 300%

USM 500%

ENHANCING SHARPNESS Most images from digital cameras or scanners will probably require some sharpening. The main problem is that different types of image, from misty landscapes through soft focus portraits to finely detailed flower portraits, will require differing amounts of sharpening. Most image processing programs have sharpening filters that apply a pre-determined amount of filtration. Some programs, however, such as Adobe Photoshop, have a sharpening filter that can be adjusted to suit the image. This is known as an "unsharp mask" filter, an unfortunate name for perhaps the most useful filter in the program.

It is essential to do some tests on your own images and your own printer, as the printed image may appear different from the image on the computer monitor. Choose perhaps two very different types of image, one with fine detail, and one without. Print examples with no filtration, and then with increasing amounts. Start with the amount set to 100 percent, the radius at 1.0, and the threshold at 1. No two photographers will agree on the right amount: it is up to you to decide what you prefer.

SIMPLE RETOUCHING The retouching of dust specks and scratches is a simple job in most image processing programs, the majority of which have a range of tools for this purpose. Simple dust specks can be spotted, as with photographic prints, using a brush or pencil tool (see Retouching Prints). The color immediately adjoining the speck can be sampled using the eye dropper tool. The color is put into the active paint palette and then used by the various brushes, pencils, and the like. For larger areas, such as long scratches, it is essential to keep sampling the color along the length of the line, and not to fill it with one color. This is a great advantage over the retouching of prints, where mixing of different grays or colors would take a very long time.

Several programs have a dust-and-scratches filter. This will automatically remove dust specks and scratches from selected parts of an image. You are usually able to set the size of dust particle to be removed. Use this filter with caution, however, and only apply it to areas of the image that have no fine detail, as it also blurs the image.

Probably the most useful of all the retouching tools found in many image processing programs is the cloning, or rubber stamp, tool. This will copy an area of the image exactly and place it in another area. You can use it like a paintbrush, but paint with a section of the image rather than just a single color. The size and shape of the cloning tool can be altered to suit the area on which you want to work.

EXPERIMENTING WITH DIGITAL RETOUCHING TECHNIQUES

This image of a boy (above left) presents several problems for the retoucher. Notice that two areas of the photograph – one ear and the lapel on the jacket – have been rubbed away over the years. To replace them, the ear on the right was selected with the lasso tool and copied. The ear was then pasted back into the image, and flipped horizontally. (Take great care when doing this because, if the lighting on the subject was directional, by flipping the selection you will be changing the lighting direction on just that part of the image, and it will look very odd.) The pasted ear was then moved into the correct position. The join was retouched using the cloning tool, which was then used to retouch other areas, such as the scratch at top right and in the boy's hair. The most difficult areas are nearly always skin tones, which require a great deal of work if they are to look natural. The whole image, for someone with a few weeks' experience, should take around 20 minutes. The image was finally converted to duotone mode, and sepia-toned (above). Since the original print was so small, just around 3in (7.5cm) high, the final resolution is relatively poor.

IMAGE MANIPULATION The topic of digital image manipulation is enormous, and has been the sole concern of many books. It can involve changing the position of elements within a single image, combining parts of different images, or even combining photographic images with images drawn in computer graphics programs. The possibilities are endless.

The simplest technique to begin with is to copy and paste parts of images. There is a range of selection tools in many programs that allow you to select areas of the image. Once selected, that part of the image can be copied (in the edit menu) and pasted back onto the image. You can then position the pasted image anywhere you like.

Some programs, such as Photoshop, allow the layering of images, whereby each pasted component is stored as a layer. Each layer is independent, and can be moved or adjusted in terms of its color, brightness, or opacity. The order of layers can be altered, so that layers can be interleaved like a book.

TONING IMAGES Monochrome digital images can be toned or hand-colored just like monochrome photographic prints, but with a much greater degree of control and without the need of chemicals. When toning prints the image mode is converted from greyscale to duotone. In fact, programs such as Photoshop have duotone, tritone, and quadtone modes.

Duotoning means that the image is composed of two colors (or inks, when printed). For example, mixing black and yellow will give a sepia effect. Varying the density and saturation of the yellow will give different shades of sepia. All of this can be controlled to a very high degree in the program. Tritoning implies the use of three inks, and it is possible to allot one color for the shadow areas, and another for the highlights. Quadtoning involves four inks.

HAND-COLORING IMAGES To hand-color a greyscale image, you must first convert into a color image (usually RGB format). You can then choose colors from the palette, and use the various brushes to apply them. You will need to experiment with the opacity settings of the paint, so that it is laid down as transparent color rather than as a solid color. Photoshop has various blend modes for doing this. Select color mode, so that the color is laid down in direct proportion to the underlying pixels.

CREATIVE FILTERS Just as photographers use glass or plastic filters to modify the light passing through a lens, so digital imagers have a range of different filters that can be applied to images. These range from simple texture and grain effects, to filters that apply a painterly effect, add flare effects, or even distort the image. They can be used in combination, and their application is limited only by your imagination.

EXPERIMENTING WITH COMPOSITE IMAGES

IMAGE 1 The boy was deliberately shot against a plain white background, so that he could be joined with the second image more easily. First, however, the background was tidied up, with the cable being removed with the "cloning" tool.

IMAGE 2 The shell, also shot on a white background, was selected using the "magic wand" tool to select the dark tones automatically.

COMPOSITE IMAGE The shell was copied and pasted onto the image of the boy, and moved around so that it fitted the boy's back perfectly by using the "layers" facility.

EXPERIMENTING WITH DIGITAL HAND-COLORING TECHNIQUES

The original greyscale image (right) was converted to RGB color mode. Colors were then chosen by trial and error using the color palette, with which hue, saturation, and brightness could be adjusted. An educated guess could be made about the hair color, but the color of the clothing is purely an arbitrary choice. The paintbrush was set to color mode, so that the color was laid down in direct proportion to the underlying pixels. Light gray became light green, and dark gray became dark green (far right).

NO FILTER *This is the original image of the eye.*

EMBOSS FILTER *This filter produces a 3D effect.*

TWIRL FILTER *This has been used to re-shape the eye.*

EXPERIMENTING WITH CREATIVE FILTERS

Various filters have been applied to this picture of an eye. Different textures have been applied, as well as distortions and radical manipulations.

DIFFUSE GLOW FILTER *This results in a sepia effect.*

SOLARIZING FILTER *This produces quite a sinister look.*

RETICULATION FILTER *This applies a network of lines.*

Printing Digital Images

The printers that are available for printing digital pictures vary in their technology, quality, and cost. Therefore, if you require the best quality for your photographs, it may be worth using a photographic laboratory that can offer a high-quality printing service.

These labs use technology that is usually too expensive for general home use. However, it is possible to achieve virtually the same quality at home on inexpensive ink jet printers as that produced by the conventional photographic process.

LASER PRINTERS The black-and-white laser printer is common in offices for printing text documents. Color laser printers are now available that give remarkably good quality when used for printing digital images, even on inexpensive paper. The printers themselves, however, are relatively expensive, although the price has fallen in recent years.

THERMAL PRINTERS There are two types of printer that use a heat process to put dye or wax onto the paper: thermal wax and thermal dye sublimation. The thermal wax process heats cartridges of wax and lays the wax down on the paper. The process is relatively inexpensive, but it does not produce photographic quality. Thermal dye sublimation gives results that are indistinguishable from photographs. The process uses ribbons containing yellow, magenta, and cyan dyes, which are laid down on top of each other to build up the required color. It is a superb process, but the machine and materials are extremely expensive.

☞
Film processing, pages 94–97
Printing film, pages 98–105
Image processing, pages 120–123

▲ INK JET PRINTER
Ink jet printers have become remarkably popular, and relatively inexpensive, over the last few years. Six-color versions produce photographic images with the best colors and tonal gradation.

INK JET/BUBBLE JET PRINTERS Most of the advances of recent years have been made in the field of ink jet, or bubble jet, printers, which produce superb quality images from remarkably inexpensive machines, provided you use the right paper and ink. Ink jet printers work by firing minute drops of ink onto the paper surface. Most have four inks: magenta, yellow, cyan, and black. However, the best ink jet printers have six inks, adding light yellow and light magenta to the previous list. This enables them to give a very rich tonal range. Two main resolutions are available, either 720 dots per inch (dpi) or 1440 dots per inch (dpi).

EXPERIMENTING WITH PRINTERS

Try sending the same image to a bureau to be output on different printers and compare the results. The picture on the left is from a laser printer, and is made up of a series of dots aligned in rows. The print below is from a thermal dye sublimation printer. No dot pattern is visible. The print shown bottom left was output on an ink jet printer. The dots are generally so small as to be invisible to the naked eye.

PREPARING IMAGES TO PRINT

For the purposes of this section, we will assume you are going to use an ink jet printer. Different printers will require similar testing procedures. As a rough guide, you will need an image with a million or more pixels (4Mb or more) in order to get a good quality 8x6in (20x15cm) print. This will vary according to the digital camera or scanner you used to get the image, and the type of image, printer, and paper.

■ Adjust the brightness and contrast of the print. Try to arrange for a consistent ambient light in the room where you are working. You might want to build a cardboard mask around the monitor to minimize ambient light falling on the screen in a sunny room.

■ Make sure you have a neutral color for the desktop of your computer. Highly colored backgrounds will affect the appearance of the color of the images. It may be worth constructing a test image, which contains some fine detail, bright colors, and perhaps an area of neutral gray.

■ Adjust the brightness and contrast of the image, so that it looks right on the monitor. You could try the test strip approach from photography (see Printing Film) and divide the image into a number of areas. Select each area individually and make them progressively lighter or darker, with varying levels of contrast. Finally, apply any necessary sharpening (see Image Processing).

■ To get the best quality from an ink jet printer, use photographic quality paper. Choose the highest resolution on the printer, either 720 or 1440 dpi. If your printer has the facility, choose the error diffusion option. This determines the pattern of dots laid down by the printer. Now produce a print and evaluate it.

■ Take the print back to the monitor to see if the monitor image differs from the print. You might need to adjust the brightness and contrast settings on the monitor to match them. Once set, do not move them.

GALLERY

ONE OF THE BEST WAYS TO IMPROVE THE QUALITY OF

YOUR PHOTOGRAPHS IS TO LOOK AT THE WORK OF OTHER

PHOTOGRAPHERS. TRY TO ANALYZE WHY YOU LIKE

SOME PHOTOGRAPHS AND DISLIKE OTHERS. LOOK

CAREFULLY AT THE LIGHTING AND TRY TO FIGURE OUT

DIRECTION, TIME OF DAY, OR, IF THE WORK WAS DONE IN

A STUDIO, HOW MANY LIGHTS THE PHOTOGRAPHER USED,

AND HOW A PARTICULAR EFFECT WAS ACHIEVED. GIVEN

TIME, YOU WILL DEVELOP YOUR OWN STYLE, BUT YOU

SHOULD NEVER STOP LEARNING, AND NEVER STOP

LOOKING AT OTHERS' PHOTOGRAPHS FOR INSPIRATION.

ARCHITECTURE

Good architectural photography requires not only a good sense of shape and form, but also an appreciation of light quality, and the way in which certain buildings appear under different lighting situations. The actual subject matter is virtually limitless, including as it does pictures of individual buildings, groups of buildings, and details of doors and windows. Remember that ordinary buildings such as houses and shops are just as valid as major commercial and artistic centers and cathedrals.

◀ CHARLES AITHIE
This unusual view of the much photographed Sydney Opera House has a strong diagonal element, giving it a sense of drama. Views such as this can be tricky to expose correctly in order to ensure that both building and sky are well-exposed.

▶ MARK HANNAFORD
This shot of St Simeon's Monastery, Syria, is beautifully lit, with early evening sunlight picking out detail in the stones and creating interesting shadow patterns. The inclusion of the moon between the two curved arches adds greatly to the overall composition.

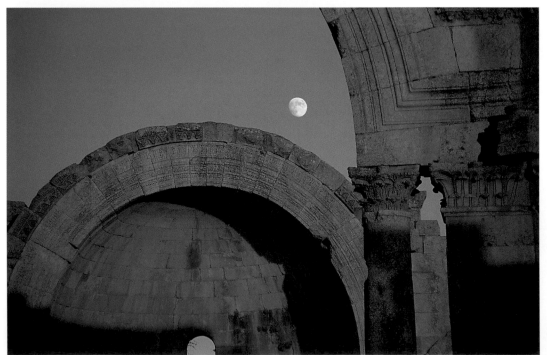

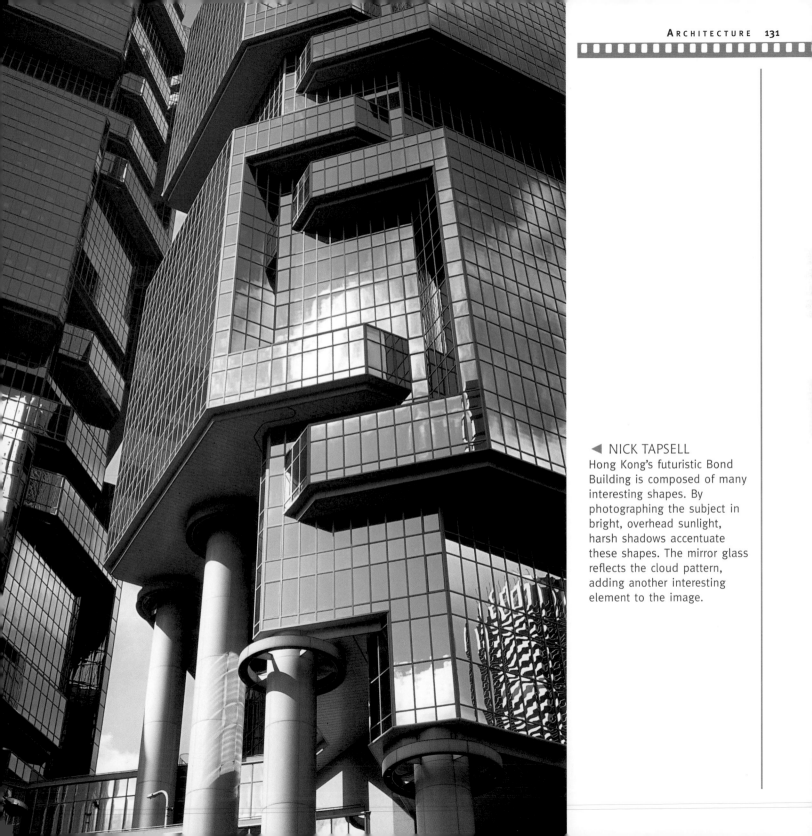

◄ NICK TAPSELL
Hong Kong's futuristic Bond Building is composed of many interesting shapes. By photographing the subject in bright, overhead sunlight, harsh shadows accentuate these shapes. The mirror glass reflects the cloud pattern, adding another interesting element to the image.

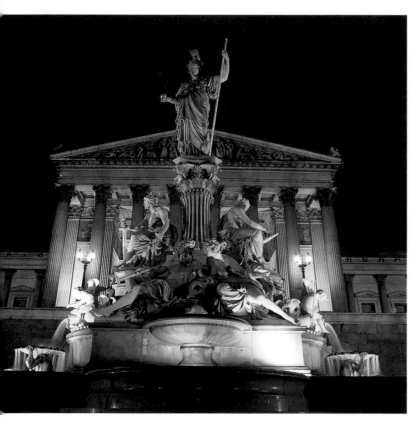

▲ CHARLES AITHIE
Many buildings, such as the Viennese Parliament pictured here, look wonderful when they are illuminated at night. Depending on the film used, some of the lights can produce color casts, such as the green cast here. In this case, the effect enhances rather than detracts from the picture. Photographs taken at twilight ensure that the sky is not completely black.

▼ ROY LAWRANCE
Modern mirror-glass buildings can be photographed in a number of different ways. In this picture, taken in Quito, Ecuador, the photographer has concentrated on a detail of the reflection within the glass. The mirror glass has distorted the shape of the building in the reflection, producing a rather surreal, abstract quality.

◀ MOIRA CLINCH
The doorway's bright primary colors and graphic patterns give this photograph its impact. To echo the bold simplicity of the scene, the picture was taken straight on rather than from an angle, but the photographer waited for the sunlight to catch the texture of the wall and cast shadows from the roof and doorway. This prevents the shot from being too flat by giving the wall a three-dimensional quality, which would have been lost had the photograph been taken in direct sunlight.

▶ N C TURNER
These extraordinary dwellings, in Ladakh Dhuktal Gompa, Zangskar, almost appear to be growing out of the rock on which they have been built. Strong cross-lighting brings out the textures in the rock and the buildings, but the sunlight is slightly hazy, ensuring that even the shadow areas have detail.

CLOSE-UP

Of all the techniques encompassed by photography, close-up is perhaps the most technically demanding, requiring good technical knowledge, meticulous attention to detail, and the ability to visualize a good image, often in an otherwise uninspiring subject. The photographer needs to improvise in order to get light into a small area, as well as to support small subjects. The examples shown here demonstrate excellent photographic technique, together with a strong grasp of the principles of composition.

▶ PETER MILLARD

"Ice and a slice" is the result of very careful lighting, choice of subject, and an element of wit. The ice cubes are plastic, while the lemon is real; carbonated mineral water produced the best bubbles. A single flash was used to make the bubbles as static as possible, but there is still movement in some of them. An electronic flash with a soft box attachment was placed directly behind the glass and masked with black paper so that only the subject itself, as seen through the lens, was illuminated.

◄ CHRIS ROUT
A photograph of pasta is a very simple shot that is easy to set up, but here it becomes something rather special because of the composition and eye for detail. The lighting came from a large soft box attached to an electronic flash, although it could equally have come from a window with diffuse sunlight. Try setting up a subject such as this near a window, and, if necessary, put tracing paper over the window to diffuse the light.

► ROY LAWRANCE
Fall leaves were placed directly onto a light box, so that the photograph could be taken entirely with light transmitted through the leaves. Overlapping the leaves allowed more or less light to be transmitted, adding a variety of tone. When photographing this way, make sure you mask off as much extraneous light as possible to prevent flare.

► ROY LAWRANCE
By isolating a section of a caravan wheel, the photographer has successfully produced an interesting abstract image. The central hub of the wheel is placed on a vertical "third," with the radiating lines of the spokes adding a dynamic quality. The background behind the wheel is thrown well out of focus, so that it does not distract from the main part of the subject.

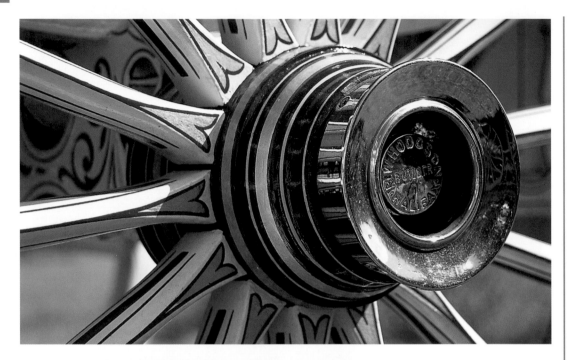

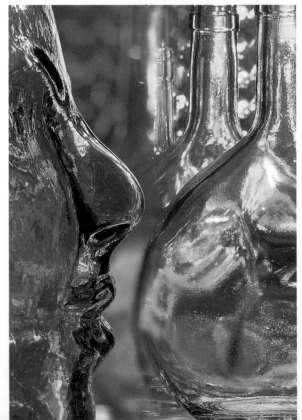

◄ DAVID CANTRILLE
"Bottle Viewing" is an interesting detail of a glass head and bottles, which have been greatly enhanced by the use of multicolored background paper, the colors of which have been distorted by the glass shapes.

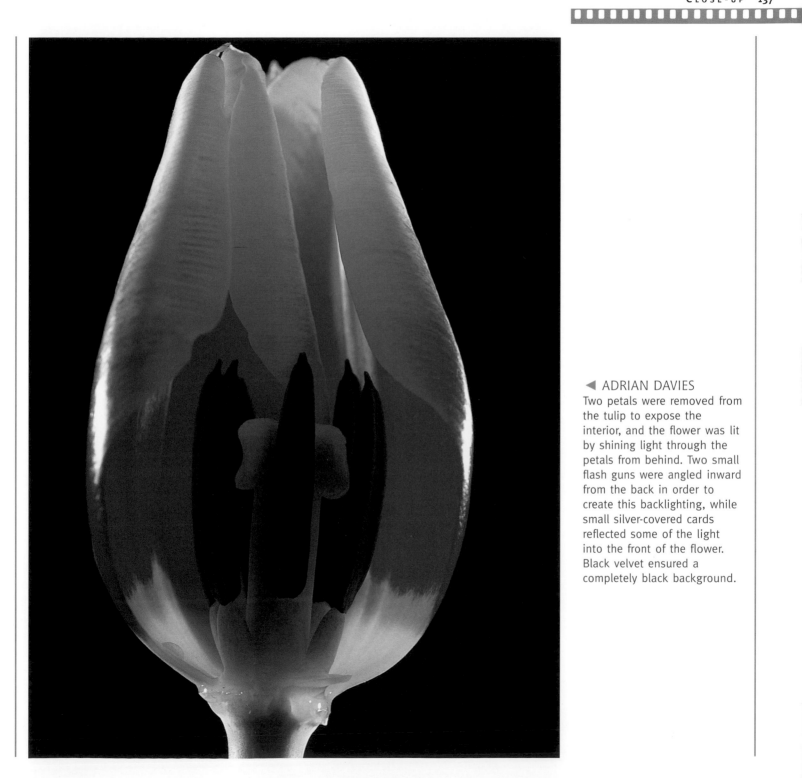

◄ ADRIAN DAVIES
Two petals were removed from the tulip to expose the interior, and the flower was lit by shining light through the petals from behind. Two small flash guns were angled inward from the back in order to create this backlighting, while small silver-covered cards reflected some of the light into the front of the flower. Black velvet ensured a completely black background.

DIGITAL

Technology for digital imaging has advanced rapidly over the last few years, bringing with it new methods for creating exciting photographs. These can be "photo-realistic" – that is, they look like conventional photographs but have been digitally manipulated – or new art forms in their own right, such as abstracts or graphics. While many of the effects would have been possible in a conventional photographic darkroom, they are usually much easier to achieve, and more successful, when done on a computer.

► McMILLAN STUDIOS
This image is typical of many digital composites now being used for advertising and a variety of other purposes. It includes a number of different elements – the girl on the mattress, stars in space, a satellite image of the Earth – that have been put together using Adobe Photoshop.

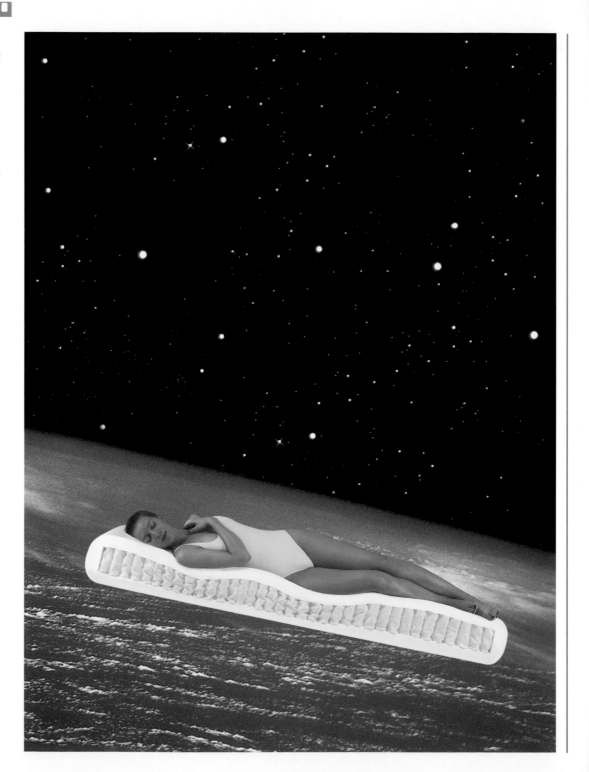

► McMILLAN STUDIOS
The term "digital imaging" does not always imply that an image has been manipulated or processed by computer. This picture of a rose was captured using a digital camera back attached to a conventional, large-format studio camera. The camera allowed a high degree of control over depth of field; in this case, a single water droplet stands out against an out-of-focus red rose. If necessary, image-processing software can be employed to enhance the out-of-focus effect using blurring filters.

▲ JAY MYRDAL
This photograph is a combination of conventional photography and computer enhancement. A monochrome photograph was taken in the studio of "rain" falling onto the umbrella. This was combined with an image of an airplane in the background. Finally, the umbrella was colored using paint tools in an image-processing program.

▲ McMILLAN STUDIOS
Atmosphere was added to this straightforward studio shot of a personal computer by using dry ice in the background and a colored gel over the flash to expose the picture. The monitor was deliberately underlit. Computer-generated streaks and text were then added, using an image-processing program such as Adobe Photoshop. Image-processing techniques can turn even the most mundane subjects into striking images, and are widely used for advertising purposes.

▶ AGELOU IOANNIS
This striking image demonstrates perfectly the potential of digital image processing when combined with a fertile imagination. Starting with simple studio shots of spectacles, the photographer has added digitally manipulated images of eyes using an image-processing program such as Adobe Photoshop.

LANDSCAPE

It could be said that landscape photography is about being in the right place at the right time, but in fact it is much more than that. Even stunning scenery can produce dull pictures if that scenery is badly photographed. Great landscape photographers may wait for hours for the right light, or walk miles to find the best viewpoint. Landscape photography also involves capturing detail – perhaps with long telephoto lenses – as well as wide vistas, using the wide-angle lenses more often associated with this branch of photography.

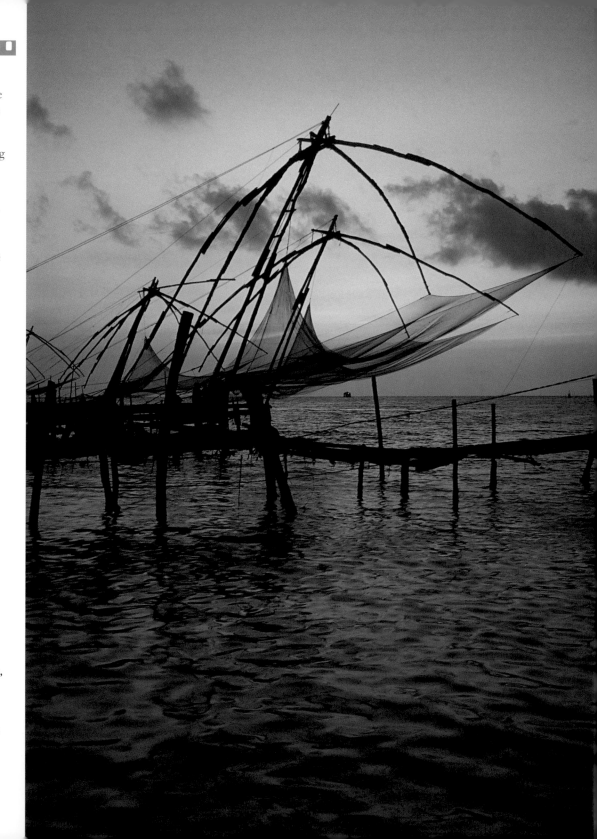

▶ JILL RANFORD
The success of this image of Chinese fishing nets being used in Kerala, southern India, depends on the intricate shapes created by the nets and the wooden structure, seen largely in silhouette. The color of the sky at sunset is mirrored in the water. The whole image has a wonderful sense of tranquillity.

► MARK HANNAFORD
Getting up at dawn often provides the opportunity to capture magical light quality, as illustrated in this photograph of rock formations at Torres de Paine, Chile. The rock towers seem to rise above the surrounding land, which is viewed in shadow. The early morning sun enhances the red of the rock.

◄ DAVID CANTRILLE
Water, in all its various forms, can be extremely photogenic, as this photograph of a waterfall and stream in the Yorkshire Dales, England, demonstrates. The photographer has chosen to use a wide-angle lens, and to show the waterfall from the end of the stream. A colored polarizing filter has enriched the colors of the water, while a relatively slow shutter speed has given the flowing water a silky appearance.

◀ JILL RANFORD
This photograph of a stunning sunset in the Everest region of Nepal demonstrates how being in the right place at the right time can be vital in landscape photography. The light striking the top of the mountains is complemented by a fascinating swirl of cloud. Such weather conditions may only last for minutes or even seconds, so they must be captured quickly.

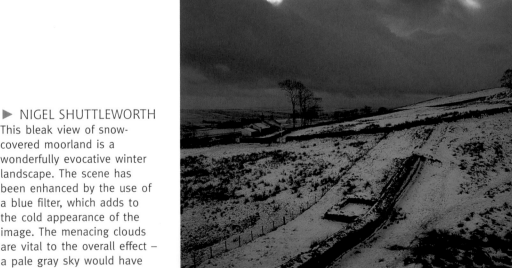

▶ NIGEL SHUTTLEWORTH
This bleak view of snow-covered moorland is a wonderfully evocative winter landscape. The scene has been enhanced by the use of a blue filter, which adds to the cold appearance of the image. The menacing clouds are vital to the overall effect – a pale gray sky would have been very dull.

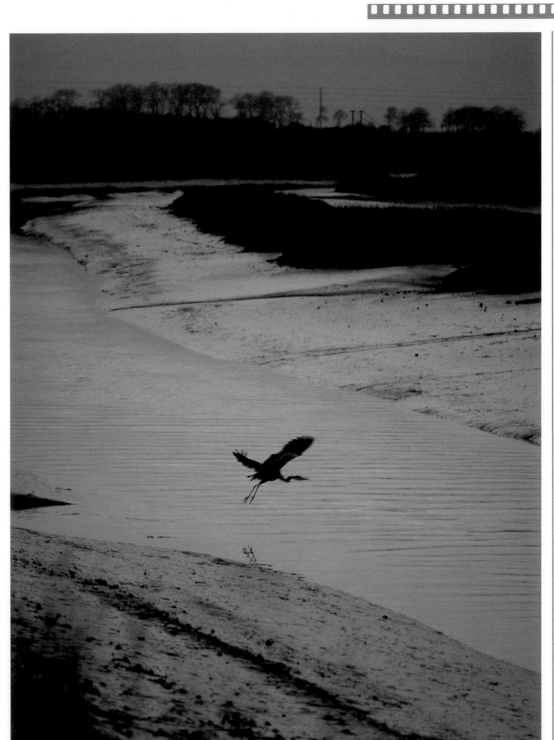

► ADRIAN DAVIES
The river, photographed at sunset, would have had little to offer had it not been for the heron taking flight. Shots such as these can rarely be planned, and therefore demonstrate the value of having your camera with you, and ready to use, at all times.

NATURE AND WILDLIFE

Photographing wildlife subjects not only demands good skills in photographic techniques, but also a sound working knowledge of your subject. Some of these can be found in your own yard, and, for beginners, this is an excellent place to start. However, for other subjects you may have to travel some distance to wilder areas and learn more about the habits of your chosen subject. Patience, too, is required – many photographers spend long hours waiting in cramped conditions for animals to arrive, or for light conditions to improve.

▶ ADRIAN DAVIES

This is an excellent habitat photograph, showing plants growing in their characteristic surroundings. While it would have been tempting to go in close to one of the fungi, a 28mm wide-angle lens has allowed the photographer to gain a broader view, showing the fly agaric toadstools growing alongside the birch trees with which they are primarily associated.

▲ JAMES DE BOUHEVIALLE
You will probably have to be patient to get this type of shot. Here, flash has been used to achieve good detail in the squirrel's fur.

▶ N C TURNER
Fall colors are perhaps best seen in deciduous woodlands, such as those found in this New England setting. In this photograph, each leaf is a kaleidoscope of red, green, and yellow, seen against a bright blue sky.

▲ ADRIAN DAVIES
Shots such as this, in particular of nocturnal subjects, need to be carefully planned, both in terms of where to find the subject and how to light it. In this case, two flash guns were used – the first heavily diffused, from top left of camera, and the second from behind and to the right of the barn owl – in order to provide backlighting.

► MARK HANNAFORD
Behavioral shots of birds and animals are always much more interesting – and difficult to achieve – than static portraits. Here, the photographer has used electronic flash to freeze the water droplets as they are thrown from the bird during routine bathing. Shots such as this can often be taken in city parks and zoos as well as in the wild.

◄ JILL RANFORD
This photograph illustrates perfectly both the extraordinary iguana of the Galapagos Islands and the desolate surroundings in which it lives. A wide-angle lens was used, quite close to the subject, so that the iguana is fairly large in the frame while still showing a significant portion of the animal's habitat. A close-up shot of the iguana would have been possible using a medium telephoto lens, but by using a wide-angle, the picture is much more informative about the creature as well as more visually interesting.

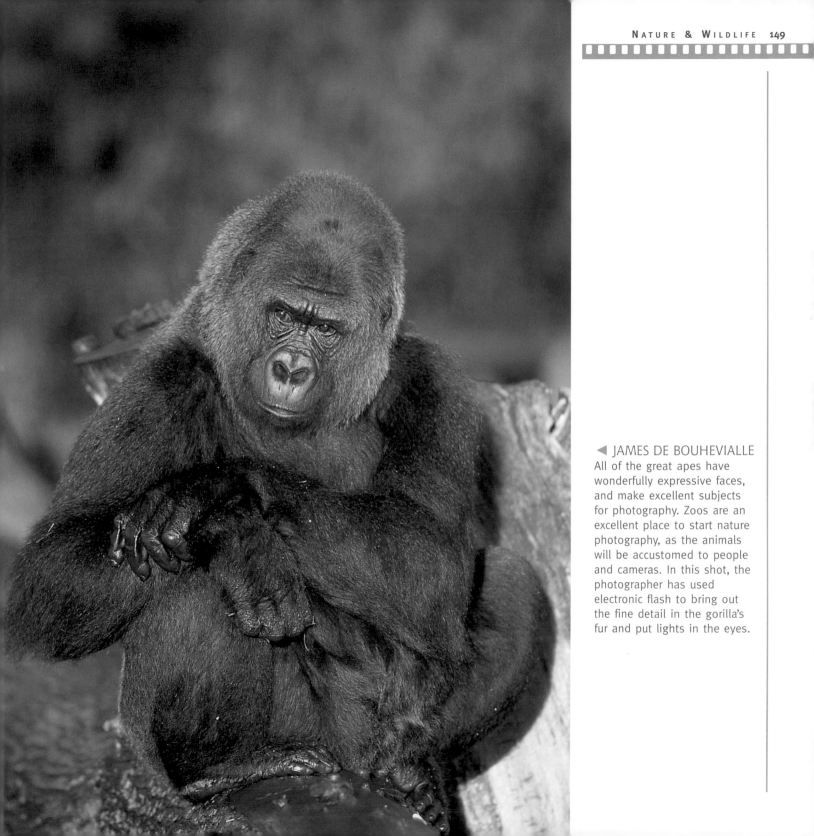

◄ JAMES DE BOUHEVIALLE
All of the great apes have wonderfully expressive faces, and make excellent subjects for photography. Zoos are an excellent place to start nature photography, as the animals will be accustomed to people and cameras. In this shot, the photographer has used electronic flash to bring out the fine detail in the gorilla's fur and put lights in the eyes.

PEOPLE AND PORTRAITS

People are probably the most common subjects for photography, ranging from studio portraits and formal occasions such as weddings, through informal events such as parties, to documentary photographs of people. Try to establish some kind of rapport with your subject, which will result in a far more relaxed portrait than if both sitter and photographer are nervous. A medium telephoto lens usually gives a more pleasing effect than a standard or wide-angle lens, and also allows you to be further away from the subject.

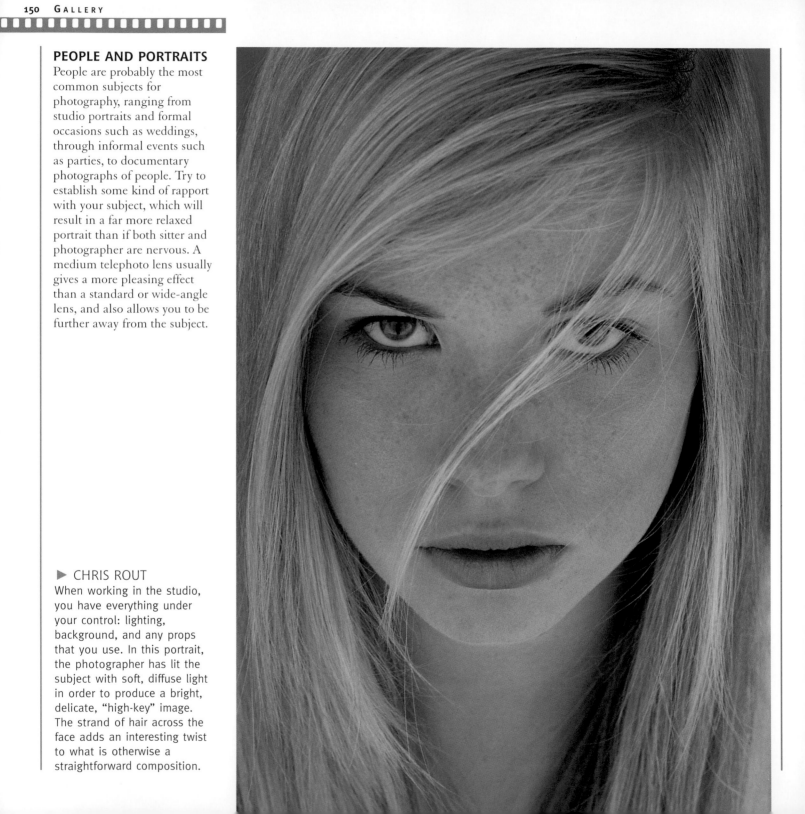

▶ CHRIS ROUT

When working in the studio, you have everything under your control: lighting, background, and any props that you use. In this portrait, the photographer has lit the subject with soft, diffuse light in order to produce a bright, delicate, "high-key" image. The strand of hair across the face adds an interesting twist to what is otherwise a straightforward composition.

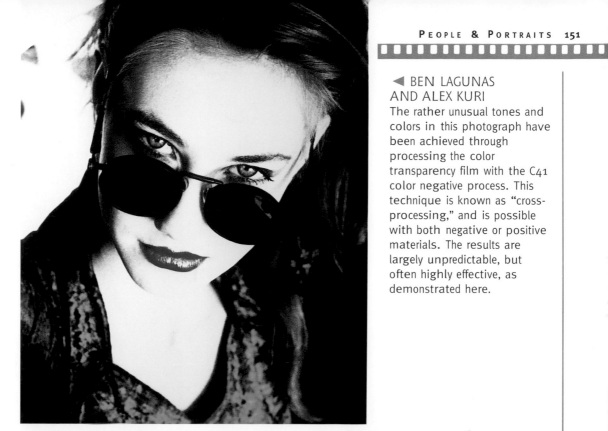

◄ BEN LAGUNAS
AND ALEX KURI
The rather unusual tones and colors in this photograph have been achieved through processing the color transparency film with the C41 color negative process. This technique is known as "cross-processing," and is possible with both negative or positive materials. The results are largely unpredictable, but often highly effective, as demonstrated here.

► PATRICIA AITHIE
The monochrome portrait seems to break many of the conventional rules of portraiture, with a dull, rather distracting background. Yet the image works well, with the main center of interest concentrated on one of the "thirds" within the image. The lack of color adds a sense of drama and mystery.

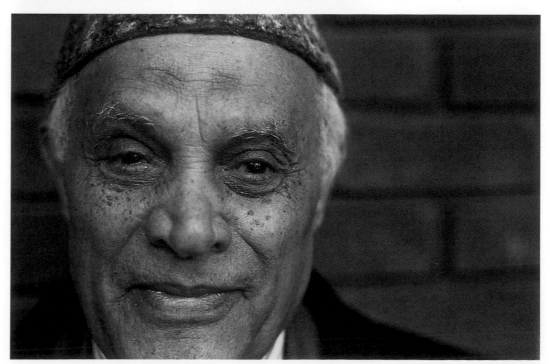

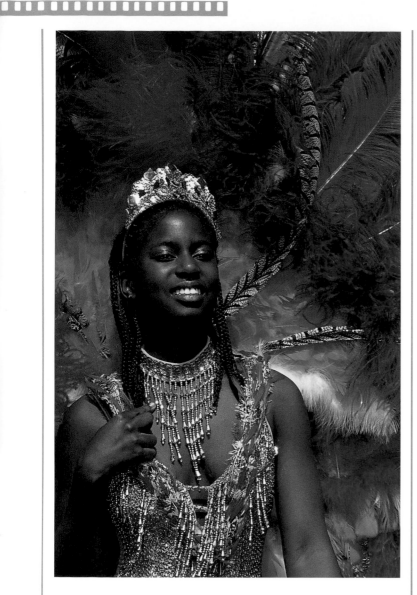

▲ BOB PEARSON
Carnivals are a great source of subject matter for photography, as this image from London's Notting Hill Carnival shows. The brilliant colors of the costume provide a vivid background for the girl, whose face is positioned off-center in the frame for an excellent composition.

▼ NICK TAPSELL
This image of a young village girl in Ludia Kutch Gujarat, northwest India, has an almost painterly quality to it, with muted colors enhanced by the soft, diffuse light. The expression in the girl's face is apprehension, not fear, and draws the interest of the viewer into the picture.

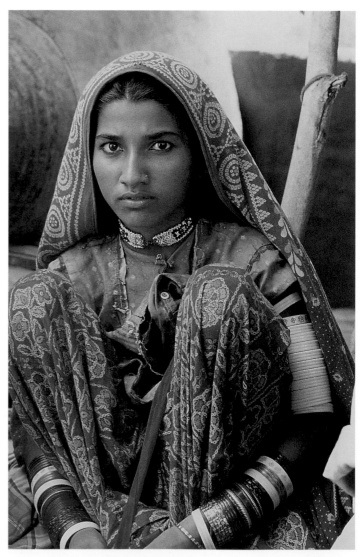

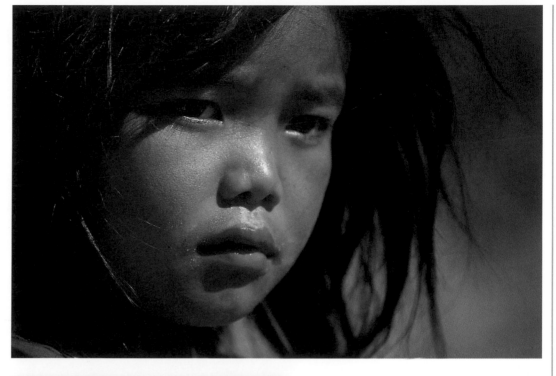

▶ JILL RANFORD
A medium telephoto lens has been used here to produce the close-up portrait of a Nepalese girl. The image almost fills the frame, so the viewer has no choice but to concentrate on the girl and her expression. For this sort of shot, try not to be too intrusive. Ask permission first, in order not to cause offense.

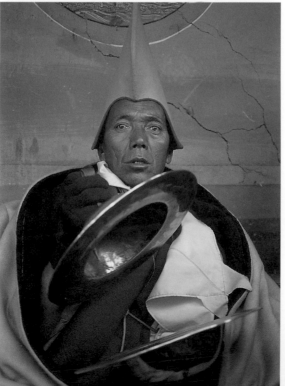

◀ JILL RANFORD
What makes this such a successful picture are the brilliant colors of the high lama's costume, together with the background and the cymbal-like musical instrument he is holding. The costume forms an almost circular shape, with the lama's hat leading the eye toward the partially obscured painting at the top of the frame.

STILL LIFE

Photographing still-life subjects is an exacting area of photography. It demands great attention to detail, good technique, and a fertile imagination with which to visualize a picture from what are often rather ordinary, everyday subjects. The studio you use need be nothing more than a kitchen table, or simply a garden shed; lighting can be a complex arrangement of several different light sources, or a single light strategically placed.

► LES WIES
This unusual shot is a wonderful combination of technique and imagination. The hammer has been constructed by a model maker, and placed among a whole variety of seemingly unrelated objects. The contrast between the smooth surface of the hammer head and the rough frame works extremely well. Most still-life photographers often keep boxes of interesting items that may one day find a place in photographs such as this.

▲ PAOLA ZUCCHI
This studio shot of figs makes superb use of limited depth of field and selective focus in order to draw the eye to the main object while at the same time giving enough information about the fruit in the background. Had the figs been more out of focus, they would merely have been amorphous blobs; if they had been any sharper, they would have distracted from the main part of the image.

▼ DAVID CANTRILLE
This interesting photograph begs a question: are the vase and background all one, or are they separate objects? In fact, they are separate, but the photographer has sprayed both with the same textured paint. The lighting used is extremely flat, almost shadowless, and serves to enhance the illusion further. This shot demonstrates perfectly how a very simple idea can make an excellent still-life photograph.

Glossary

Aerial perspective The contrast between light and dark tones in landscape photography, whereby tones in the distance appear lighter than those in the foreground, producing an exaggerated effect of depth.

Analog A signal representing sound or vision by electrical analogy; eg, variations in voltage produce variations in brightness.

Angle of view The angle, or field, of view given by a particular focal length of lens; eg, in a 35mm camera, a 50mm lens gives an angle of 46°, a 28mm lens an angle of 74°.

Aperture The opening in the lens through which light passes.

Aperture priority An exposure mode on modern cameras whereby you set the aperture on the lens according to the depth of field you require; the camera automatically sets the corresponding shutter speed.

Autofocus The ability of most modern cameras to focus automatically.

APS (Advanced Photo System) A film format introduced in 1996, primarily aimed at the amateur photographer. A magnetic layer on the surface of the film stores information, such as light source, date and time, and so on. After processing, the film is returned in its cassette, together with a set of miniature prints.

Bracketing A number of exposures made on either side of the estimated correct exposure, to ensure that, in tricky lighting situations, the correct exposure is obtained.

Burning in Giving part of a print more exposure than other areas when exposing it under an enlarger.

Camera Any lighttight box that admits controlled amounts of focused light onto a light-sensitive surface, such as film or a CCD.

CCD (Charge Coupled Device) The sensing unit found in most digital cameras, which replaces the film used in ordinary cameras. It consists of a rectangular grid (area array) of light-sensitive picture elements (pixels) that generate an electrical current according to the amount of light they receive. In desktop scanners, a single row of pixels (linear array) is moved to scan the image.

CD ROM (Compact Disk, Read Only Memory) A 4¾in (120mm) diameter circular plastic disk used for optical storage of digital data. A single CD ROM holds up to 650 Mb of data. There are many different types, including audio CD, PhotoCD and CD-R (CD Recordable).

Center-weighted metering Where the light meter reading is made predominantly from the center part of the image frame.

Color compensating filter (CC filter) A light filter used to make small changes to the color balance of an image. CC filters are available in six colors (red, green, blue, yellow, magenta, and cyan) and in various strengths.

Color conversion filter A light filter used to convert a film balanced for a particular color temperature to another light source; eg, daylight-balanced film used in tungsten lighting requires an 80A filter.

Color temperature A measure of the relative amount of red or blue light in a particular light source. A tungsten light has a relatively high proportion of red and orange light (and a low color temperature), while an electronic flash has a higher proportion of blue light (and has a higher color temperature). Color temperature is measured in units called degrees Kelvin. Color temperatures may vary between 4600K for tungsten light, to approximately 9600K under clear blue, daylight conditions.

Depth of field Also known as the zone of focus, this is the distance in front of and beyond the focal point that is acceptably sharp. This will vary depending on the focal length and aperture of the lens in use.

Developer The alkaline chemical that converts exposed silver halide crystals into the silver grains that form the permanent image on the emulsion of the film.

Digital data A series of binary numbers (that is, a series of numbers composed solely of zeros or ones) that form discrete packets of information. Analog data consists of continuous, varying information; analog signals are converted into digital so that computers can recognize them.

Dodging Giving part of a print less exposure than other areas when exposing it under an enlarger.

Dots per inch (dpi) The number of digital dots per inch making up the image produced by a digital printer, or the resolution of a digital scanner. The higher the number of dots per inch, the better the quality of the print or image. (Photographs have continuous tone, which is only limited by the grain size of the photographic emulsion.)

Emulsion The light-sensitive mixture of metal (usually silver) halide and gelatin that is coated onto film or paper.

Enlarger A device used for projecting light through a negative onto light-sensitive photographic paper to produce enlarged prints.

Exposure The amount of light to which film or a CCD sensor is exposed. It is regulated by the time (shutter) and size of aperture.

Exposure compensation Compensating for false readings made by automatic light metering systems by manually adjusting the exposure. There are many instances when this may be necessary, such as when photographing predominantly dark or light subjects.

Extension tube A hollow tube inserted between the camera body and lens, to extend the distance between the two. This allows subjects to be photographed much closer than normal.

F number (f) The scale of numbers that signify the aperture of the lens – $f2.8$, $f4$, $f5.6$, and so on – sometimes referred to as stops. The figure is derived from the size of the opening through which the light passes, and the focal length of the lens. The smaller the f number, the larger the aperture, and therefore the more light passes through the lens.

File size The size of a digital file, usually expressed in kilobytes (Kb) or Megabytes (Mb).

Fill-in The addition of light into shadow areas of a photograph in order to reduce overall contrast. It may be accomplished by directing a separate light source into the required area, or by reflecting light back into the shadows with a reflector.

Film The light-sensitive medium used in many cameras, consisting of a plastic base coated with a light-sensitive emulsion.

Film speed The sensitivity of a photographic film, expressed in ISO. A 50 ISO film is relatively "slow," while a 400 ISO film is relatively "fast."

Filter In photography, a glass (or plastic) sheet placed over the front of a lens in order to modify the light passing through it. In digital image-processing software, filters are used to sharpen, blur, or apply a large number of special effects to digital images.

Fixation The process of removing unexposed silver halide crystals with an acid, making the film insensitive to further exposure.

Flare Unwanted light scattering within the lens, resulting in a loss of contrast in the final image. Flare is caused by pointing the camera toward a light source, and/or not using a lens hood.

Flash A high-intensity, short-duration spark in a gas-filled glass tube, caused by the discharge of a high voltage from a capacitor. Electronic flashes vary from small portable units, often built into the camera, to large studio-based systems.

Focal length An indication of the angle of view of a lens. A short focal length lens has a wide angle of view, and vice versa.

Grain The structure of a photographic image, made up of irregular masses of metallic silver. Film can be fine or coarse grained. Many photographers use coarse grain for pictorial effect. Usually the faster a film, the larger the grain.

Incident light metering The use of a light meter at the subject's position that measures the amount of light falling on (incident on) the subject.

ISO (International Standards Organization) The scale used to designate the sensitivity, or speed, of a film or CCD.

Joule A measure of the light output from electronic flash systems.

JPEG (Joint Photographic Experts Group) A means of storing digital image files that compresses them so that they take up less space. JPEG uses a "loss" compression system, so some data will be lost during the process.

Lens The combination of glass elements used to focus light onto the light-sensitive film or CCD sensor.

Lens hood A device that is attached to the front of a lens to prevent flare.

Light-balancing filter A range of slightly colored filters used to "cool down" or "warm up" the colors in a photograph.

Manual exposure A facility that gives the photographer complete control to use his/her judgment over both shutter speed and aperture. The in-built light metering system can be used to assist this judgment.

Modeling light A continuous tungsten light built into some electronic flash units that enables the photographer, normally under studio conditions, to preview a lighting effect.

Neutral density filter An almost colorless, gray used to reduce the amount of light passing through a lens.

Parallax The difference in viewpoint given by two different lenses, such as the viewing lens and the taking lens in a compact camera. At short taking distances, the error induced by parallax can cause major framing problems.

PhotoCD A system developed by Kodak of digitizing 35mm negatives or transparencies onto a CD ROM. Each image is stored at five different resolutions. A professional version – ProPhotoCD – gives higher resolution, and allows larger originals to be digitized.

Picture CD A system similar to PhotoCD, but with lower resolution and only one version per image, aimed at 35mm or APS users.

Pixel (Picture Element) The smallest unit of a digital image.

Polarizing filter A light filter used to minimize reflections from non-metallic surfaces, or to increase color saturation. It has no effect on exposure time.

Programmed mode An automatic exposure mode whereby the camera controls both the shutter speed and aperture.

Reciprocity failure The loss in effective sensitivity of film at very long or very short exposure times. If an exposure meter indicates that four seconds is the required exposure, then an actual exposure of perhaps eight seconds may be required to give the correct density on the film.

Reflected light metering Measuring the amount of light that is reflected from a subject.

Resolution The ability to resolve (see) detail. All components of photographic and imaging systems have their own resolution capabilities. In film, the ultimate resolution is governed by the size of the silver grains on the emulsion. In digital imaging, resolution is limited by the number of pixels in an image.

Scanner A device for converting analog photographic images into digital images. Two main types are available: flatbed scanners, used primarily for prints; and film scanners, for negatives and transparencies (combined flatbed/film scanners are also available).

Shutter priority An exposure mode on modern cameras whereby the photographer sets the shutter speed according to the amount of subject movement, and the camera automatically sets the corresponding aperture.

Skylight filter A very pale filter used to absorb ultraviolet light. It has the effect of reducing blue casts on color photographs.

SLR (Single Lens Reflex) A type of camera where the subject is viewed through the same lens that takes the picture, usually via a mirror and glass prism.

Spot metering A facility for measuring the amount of light reflected from a very small but key area of a subject, such as a skin tone.

Stop bath A weak acid solution used to stop the development process immediately, prior to the fixation process.

Telephoto lens A lens with a relatively long focal length (eg, 300mm) that contains optics that reduce the physical length of the lens.

Test strip A method used to determine the correct exposure for a print by making several exposures onto the same sheet of paper.

Thumbnail A small, low-resolution version of a digital image used for previewing or cataloging images.

Toning The chemical alteration of the color of a monochrome photographic print; eg, sepia toning. Altering the color of a monochrome digital image with image-processing software.

Ultraviolet light Wavelengths of light shorter than blue light. Ultraviolet light is generally invisible to the human eye, but not to photographic film, which under certain conditions can appear too blue or be overexposed. A skylight filter can be used to absorb ultraviolet light.

Wide-angle lens A relatively short focal length lens (eg, in 35mm photography, one of 28mm), often used for landscape photography.

Zoom lens A variable focal length lens (eg, 35–70mm or 80–200mm) that enables the photographer to adjust the picture framing quickly without changing the lens.

Index

Page numbers in *italics* refer to
photographs in Gallery section

Credits

Quarto would like to thank and acknowledge the following for their contributions (key: *l* left, *r* right, *c* center, *t* top, *b* bottom):

p1 Adrian Davies; p2 Adrian Davies; p6 Roy Lawrance/ffotograff; p7 Nigel Shuttleworth; p8 Mark Hannaford; p10*l* courtesy of Nikon, *r* courtesy of Canon; p11*b* courtesy of Nikon; p12*r* courtesy of Bronica; p13*r* courtesy of Hasselblad; p14*bl* courtesy of Kodak, *c* courtesy of Nikon, *tr* courtesy of Polaroid, *br* Ian Took/Biofotos; p16*b* Adrian Davies; p17*t* Adrian Davies; p20*cr* Adrian Davies, *br* Patricia Aithie/ffotograff; p22*tl* Patricia Aithie/ffotograff; p24*t* Patricia Aithie/ffotograff; p26*l* courtesy of Canon; p27*l* courtesy of Nikon; p28*t* Adrian Davies; p29*tl* Patricia Aithie/ffotograff; p30*tr* Marc Joye; p31*tl* Patricia Aithie/ffotograff, *r* courtesy of Bronica; p32*tl* courtesy of Canon, *br* Patricia Aithie/ffotograff; p34*tl* Patricia Aithie/ffotograff, *br* courtesy of Multiblitz; p35*b* Patricia Aithie/ffotograff; p38*l* courtesy of Hoya; p39*tr* Ron McMillan; p40 Nigel Shuttleworth; p42*tr* Nigel Shuttleworth, *cr* Rosa Rodrigo, *br* Adrian Davies; p43*l* David Cantrille, *tr* Matt Leighton; p44*tr* Matt Leighton, *br* Patricia Aithie/ffotograff; p45*tl* Adrian Davies, *bl* Patricia Aithie/ffotograff, *tr* Agelou Ioannis; p46*tl* Patricia Aithie/ffotograff, *tr&br* Adrian Davies; p47*t* Patricia Aithie/ffotograff, *bl&br* David Cantrille; p48*br* Patricia Aithie/ffotograff; p49*tl&tr* Patricia Aithie/ffotograff, *br* David Cantrille; p50 David Cantrille; p51 Adrian Davies; p52*t* Charles Aithie/ffotograff, *b* Matt Leighton; p53*t* Matt Leighton, *b* David Cantrille; p54 Paola Zucchi; p55 Patricia Aithie/ffotograff; p56 Getin Özer; p57 Nicola Hancock; p59*tr* courtesy of Hoya, *br* Adrian Davies; p60 courtesy of Hoya; p61*t* courtesy of Hoya, *b* Nigel Shuttleworth; p62 David Cantrille; p63*t* Getin Özer, *b* Ron McMillan; p64 Patricia Aithie/ffotograff; p65 Les Wies; p66*t* Pat Aithie/ffotograff, *b* Jon Bouchier; p67*t* Patricia Aithie/ffotograff, *b* Ron McMillan; p68*t* Patricia Aithie/ffotograff, *b* Jon Bouchier; p69 Paola Zucchi; p70 Ron McMillan; p71*t* Adrian Davies, *b* Patricia Aithie/ffotograff; p72*tl&bl* Adrian

Davies; p73 Nigel Shuttleworth; p74*t* Patricia Aithie/ffotograff, *b* Nigel Shuttleworth; p75 Patricia Aithie/ffotograff; p78 McMillan Studios; p79*t* Adrian Davies; p80*t* Adrian Davies, *b* Patricia Aithie/ffotograff; p81 Nigel Shuttleworth; p82 Nigel Shuttleworth; p83 Patricia Aithie/ffotograff; p84 Patricia Aithie/ffotograff; p85*t* Adrian Davies, *b* Patricia Aithie/ffotograff; p86 Patricia Aithie/ffotograff; p87*tl&bl* Patricia Aithie/ffotograff, *cr* Adrian Davies; p89*t* Patricia Aithie/ffotograff, *b* Rosa Rodrigo; p90 Agelou Ioannis; p100*br* Nicola Hancock; p101*tl* Nicola Hancock; p103*cl* Adrian Davies; p107*t* Ben Lagunas & Alex Kuri, *b* Ron McMillan; p109*l* Patricia Aithie/ffotograff; p111 Patricia Aithie/ffotograff; p114 courtesy of Apple; p118 courtesy of Ricoh; p119*t* courtesy of Ricoh, *b* Adrian Davies; p120 Adrian Davies; p121 Adrian Davies; p122 Adrian Davies; p123 Adrian Davies; p124 Matthew Leighton; p125 Adrian Davies; p126*tr* courtesy of Epson; p127 Adrian Davies; p128 Les Wies; p130*t* Charles Aithie/ffotograff, *b* Mark Hannaford/ffotograff; p131 Nick Tapsell/ffotograff; p132*l* Charles Aithie/ffotograff, *r* Roy Lawrance/ffotograff; p133*t* Moira Clinch, *b* NC Turner/ffotograff; p134 Peter Millard; p135*t* Chris Rout, *b* Roy Lawrance/ffotograff; p136*t* Roy Lawrance/ffotograff, *b* David Cantrille; p137 Adrian Davies; p130 McMillan Studios; p131*t* Jay Myrdal, *b* McMillan Studios; p140 McMillan Studios; p141 Agelou Ioannis; p142 Jill Ranford/ffotograff; p143*t* Mark Hannaford/ffotograff, *b* David Cantrille; p144*t* Jill Ranford/ffotograff, *b* Nigel Shuttleworth; p145 Adrian Davies; p146 Adrian Davies; p147*tl* James de Bouhevialle/ffotograff, *tr* Adrian Davies, *b* NC Turner/ffotograff; p148*t* Mark Hannaford/ffotograff, *b* Jill Ranford/ffotograff; p149 James de Bouhevialle/ffotograff; p150 Chris Rout; p151*t* Ben Lagunas & Alex Kuri, *b* Patricia Aithie/ffotograff; p152*l* Bob Pearson/ffotograff, *r* Nick Tapsell/ffotograff; p153 Jill Ranford/ffotograff; p154 Les Wies; p155*l* Paola Zucchi, *r* David Cantrille

All other photographs and illustrations are the copyright of Quarto.